IMAGES
of America

OSTERVILLE

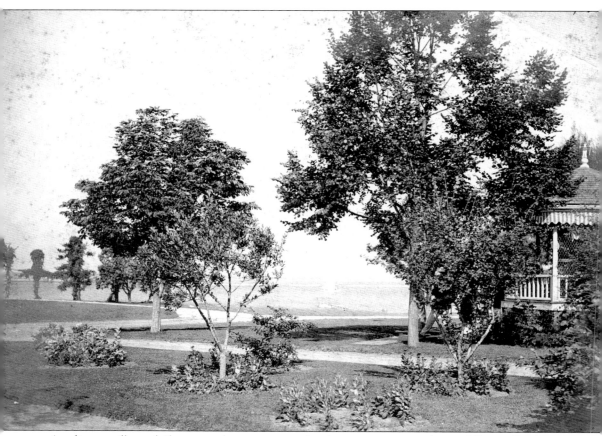

A solitary sailboat drifts across the seascape under the summer sun in front of Osterville's East Bay Lodge. The inn was considered one of the most desirable guesthouses on the Atlantic coast, and it was the place to see and be seen for those with the means to vacation on Cape Cod in the early 1900s.

On the cover: Osterville boatbuilders, led and inspired by the talented Crosby family, gained fame as superior craftsmen as early as the 1820s. Here, Charles Crosby (left), who ran his own shop in Osterville for 57 years, shows off one of his craft to Providence business executive, Osterville summer resident, and yachtsman Andrew Johnson (right) and a friend. Born in 1853, Charles went to work as an apprentice in the family workshop when he was 14 and spent most of his 82 years creating superior sailboats. (Courtesy of the Osterville Historical Society.)

IMAGES
of America

OSTERVILLE

Shirley Eastman

ARCADIA

Published by Arcadia Publishing
Charleston SC, Chicago IL, Portsmouth NH, San Francisco CA

Printed in the United States of America

Library of Congress Catalog Card Number: 2005931673

For all general information contact Arcadia Publishing at:
Telephone 843-853-2070
Fax 843-853-0044
E-mail sales@arcadiapublishing.com
For customer service and orders:
Toll-Free 1-888-313-2665

Visit us on the Internet at http://www.arcadiapublishing.com

Golfers taking a break from a tough game at the Seapuit Course on North Bay could bask in this serene view of St. Mary's Island, one of several islands off the Osterville mainland that can be reached only by causeways. The exclusive Seapuit Club, with 50 guest rooms, stood nearby but was taken down in 1932. A few years later, the adjoining clubhouse also closed. The neighborhood is now home to several large and lovely houses.

CONTENTS

ACKNOWLEDGMENTS

The creation and publication of *Osterville* would have been a much more difficult, if not impossible, project if not for the painstaking research done years ago by one man, Paul Chesbro. His three books, *Osterville*, *Osterville Volume II*, and *Osterville: A Walk Thru the Past* (written with Chester A. Crosby III) provided me with family trees, sketches of lifestyles, and even bits of gossip that I could never have found elsewhere. Paul also served as my proofreader.

And I certainly could not have written this book without the help and guidance of the Osterville Historical Society. Executive director Susan McGarry gave me unlimited access to the extensive collection of photographs housed at the society's headquarters. Before I borrowed the pictures, Susan, archivist Alice Alger, and former society president Jim Eastman spent countless hours preserving the images on the society's computer so there would be a permanent and accessible record of the treasures they have on their shelves. Also, thanks to members Andrea Leonard, Cathy Wright, and David Trimble for their advice and suggestions.

And finally, without a doubt, there are a number of Osterville families whose histories are not to be found in this small volume but should be. Our selection of photographs was limited by the publisher's strict guidelines. If we were not able to include your family pictures, we apologize.

—Shirley Eastman

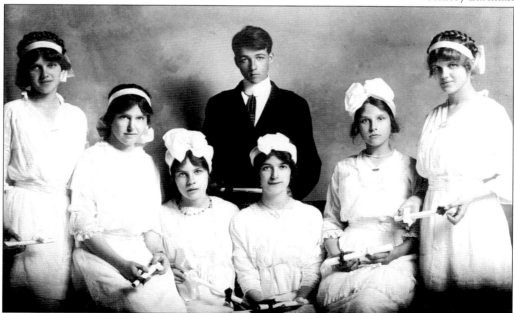

Fred Nute was the only boy in Osterville Grammar School's ninth-grade graduating class in 1914. Surrounding him from left to right are classmates Josephine Crosby, Margaret Cross, Jessie Boult, Isabel Lewis, Hazel Ames, and Emily Crosby. Osterville boys and girls who continued their education went on to Barnstable High School in Hyannis. When the United States entered World War I in 1917, Nute joined up, trained to be a pilot, and rose in rank to second lieutenant in the aviation service.

INTRODUCTION

The Native American Cotochese who lived along the shores of three sheltered bays off Nantucket Sound named them chunkoo, or chunkomuck, skunkomug, or skonkonet. But, no matter what they chose to call them, they pried open the crinkly white shells and found exactly what they were looking for, oysters.

It did not take long for the first colonial settlers, who arrived here in 1639, to learn to relish the seaside delicacy also. And so they named this quiet stretch of southern Cape Cod, Oyster Island Village. In 1648, a delegation led by Capt. Miles Standish negotiated a deed to the area with the Cotochese on behalf of Plymouth Colony, and Oyster Island Village belonged to the English. Later, the townspeople changed the name to Oysterville, and finally, in 1815, they voted to shorten it to Osterville, and so it remains. Today, the most exclusive and remote enclave of the village still bows to the bivalve and calls itself Oyster Harbors. Our Arcadia book, *Osterville*, takes this tiny seaside village from the 1600s into the 20th century, from an oyster-only community to a haven for boaters, swimmers, sports enthusiasts, shoppers, history buffs, and people watchers.

Perhaps the most distinctive feature of Osterville is the presence of the Crosby Yacht Yard, which is known worldwide for building superior catboats, Wianno Juniors, and Wianno Seniors. Pres. John F. Kennedy's Wianno Senior, seen in photographs across the globe while he was in office, was crafted and stored here. It all began in 1850 when C. Worthington and Horace S. Crosby went into the boatbuilding business on the advice of their father, Andrew Crosby. Actually, it was their father's ghost who made the suggestion to their mother, spiritualist Tirzah Lovell Crosby, who relayed it to her sons. They heeded its counsel and set up shop on West Bay. Their first boat was christened *Little Eva*.

At first they cut their own timber and sawed their own planks, and turned out only one boat a year. As time went by, they were joined in their enterprise by C. Worthington's son Danie and a host of other family members who brought their individual expertise into the business. Together, the Crosby clan created and developed unique catboats, plus the famous Wianno Senior, that by 1930 were considered to be the prettiest and fastest boats of their kind on the water.

Though most villagers did not make their living by building boats, many of them went to sea at an early age as cooks or cabin boys. The most talented and intrepid rose to captain their own schooners. Some sailed regularly to the West Indies and even China in search of whales or goods to trade. Those who stayed on land farmed, opened small businesses, educated their children, and kept the home fires burning.

Around the mid 1800s, word got out to the rest of the world that Osterville was a cool and beautiful spot to spend the summer. Wealthy families, mostly from Boston, began to visit, and several Osterville families who had large homes created guesthouses. Before long the families began building their own summer cottages and invited their friends to do the same. Within just a few years, there arose three exclusive summer neighborhoods, Wianno, Seapuit, and Oyster Harbors.

About the same time, immigrants from Portugal and the Cape Verde Islands, off the coast of Africa, began to settle in Osterville as well as on the rest of Cape Cod. They were hard-working people, dedicated to building a future for themselves in their new land. Today, Osterville is home to people of many histories and lifestyles, and the village has been enriched by their heritages. Their stories are being preserved by the Osterville Historical Society, which was founded in 1931

by Dr. Fritz B. Talbot, a Boston pediatrician and a summer resident of the Wianno section. Five other residents were charter members, J. Milton Leonard, Genieve Leonard, Margerie Leonard, Sarah Boult, and Minnie Allen. J. Milton Leonard was elected its first president.

Since 1961, thanks to the generosity of Gladys Brooks Thayer of New York and Oyster Harbors, the society has been based in the stately Capt. Jonathan Parker House, which was built in 1824. Before 1949, the museum's collection was housed in the old community center, formerly the Dry Swamp Academy primary school. A fire at the center that year convinced the society to move its artifacts to the Daniel Crosby House on Bay Street where they stayed for 12 years. Since 1979, the Osterville Garden Club has planted and maintained the society's authentic colonial and herb gardens.

One

FOUNDING FAMILIES

Lovell, Crocker, Cammett, Hallett, Parker, Leonard, Scudder, Crosby, Ames, Phinney, Bearse, and West—these early Osterville families, and a handful of others, merged and merged again over the years combining generation after generation of villagers into one large extended family. There were so many Lovells living in Osterville in the 1800s that people called it "Lovells' Neighborhood." Capt. Robert Austin Lovell, son of "Deacon" Robert and Jerusha Lovell, was born in 1817 and died in 1900. Although Lovells had been living in what is now Osterville since the late 1600s, many consider Austin and his 13 brothers and sisters as founders of Osterville's Lovell clan. Sarah Wing married Austin in 1842, and the two were man and wife for nearly 60 years.

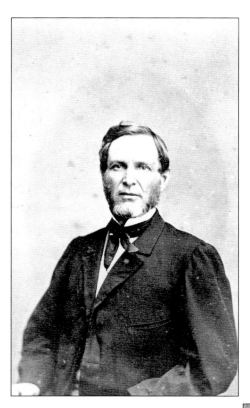

Born in 1812, Capt. Lot Phinney followed his boyhood friends to sea when he was nine years old and became master of a ship at 24. For 15 years, he commanded the steamer *Massachusetts*, which carried passengers and supplies from New Bedford to Nantucket. During a terrific gale in 1842, he and his crew rescued 35 persons stranded off the island on the whale ship *Joseph Starbuck*. Five years later, they pulled the ship *Louis Philippe* to safety before it sank in another fierce storm. Phinney and his wife, Julia Robbins Phinney, had five children, but only one, Stella, survived to adulthood.

Harriett Coffin Crosby Ames lived to acquire three of the most prominent surnames in early Osterville. Born on Nantucket to Cromwell and Mary Coffin in 1817, she first married Cyrus Crosby and moved to Osterville. Within a few years, Cyrus died and left her a widow. Her second husband was widower Josiah Ames who was 12 years older than Harriet and already had seven children. He and Harriet had six more.

Martha Crocker, the daughter of Isaiah Crocker and Elizabeth Holway Crocker, married Israel Crocker in 1865. She and her husband ran the Fancy Groceries and Meats store. Her father, a blacksmith, did ironwork for Cape Cod–based schooners and sea captains. For eight years, her father's shop doubled as Osterville's post office. Mail arrived in Osterville via stagecoach from Sandwich, a major Cape Cod port. In 1851, before they were married, Martha's future husband, son of John and Ruth Crocker, had gone off to California and Nevada to prospect for gold. Their son Maurice married Mary Lovell, and their son Edward married Mercy Leonard, further entwining Osterville's founding families.

Freeman Scudder takes a stroll along Main Street near Parker Road with grandchildren Stuart and Wilson, sons of Walter Scott Scudder. Freeman and his wife, the former Marietta Hinckley, also had a daughter, Prudence, who married Warren Lovell. Freeman and his brother Charles ran a coal, hay, and grain import business and maintained a wharf on West Bay where freight schooners made deliveries. He also operated the hay scales in the center of the village. Born in 1833, Freeman died in 1901. He was a lifelong member of Osterville's Methodist Episcopal Church.

Judge Henry A. Scudder, son of Josiah Scudder Sr. and Hannah Lovell Scudder, graduated from Yale Law School in 1842 and rose in his profession to membership on the Superior Court of Massachusetts. He also spent three years in the Massachusetts legislature. In 1864, he served as a delegate to the Republican National Convention when Pres. Abraham Lincoln was nominated to serve a second term.

Sara Fish Adams, daughter of Thomas and Hannah Fish, was the wife of Bethuel Adams, who ran a village store in Osterville. They had six children, and two sons, Watson and Isaiah, fought in the Civil War with the Massachusetts Union troops. Both Bethuel and Sara died in 1900; he was 86, and she was 80. They had been married 63 years.

During the mid to late 1800s, Capt. William Parker piloted his trading sailing ship, schooner *Abbie Bursley*, up and down the east coasts of North and South America. He often took along his wife, Jennie Bearse Parker, and their two children, Horace and Louise. Sometimes his sister, Hattie Parker, made the trip as well. In the winter, his cargo regularly included ice bound for New York City. After retiring from the sea in 1895, the captain took over the duties of Osterville postmaster.

Simeon Leonard, who was born in 1819, grew up to become the village blacksmith and one of the most prosperous farmers in Osterville. He outlived two wives, Temperance Ames and Mercy Parker. Upon his death in 1896, he left a third wife a widow.

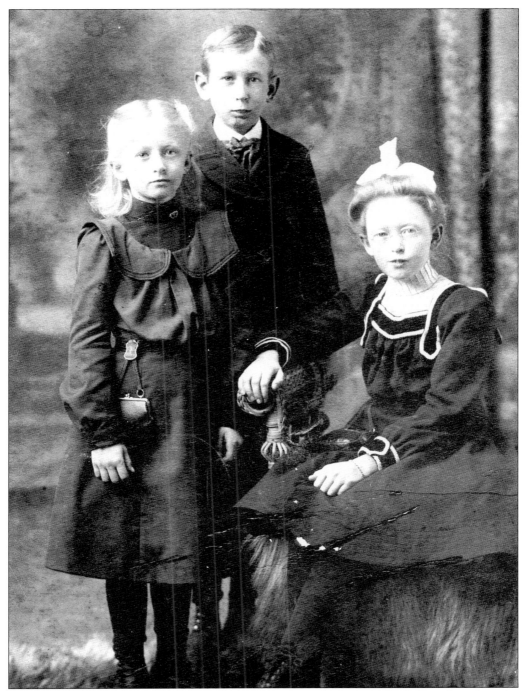

Simeon Leonard's grandchildren Margerie, Burleigh, and Genieve dressed in their best for a formal photograph taken by Chandler Seaver of Hyannis. Their father was James Milton Leonard, who ran the village bicycle shop and auto garage. James also operated the "barge," or bus, that transported passengers to and from the West Barnstable train depot and carried children back and forth to high school in Hyannis.

In 1914, when he was 43, Horace Manley Crosby built a 26-foot sloop with a combination centerboard-keel, which he had designed to ride the steep chop of Nantucket Sound. H. Manley's revolutionary craft turned out to be the prototype for the now world-famous Wianno Senior. By 1976, the Crosby shop had turned out 160 of these feisty boats including the *Victura*, commissioned by Cape Cod summer resident Joseph Kennedy for his teenage sons, Joe and John. If it had not been for one of Manley's alert and agile uncles, the master boatbuilder might never have achieved all he did. Manley nearly drowned at age six when he fell out of a boat, but his kinsman rescued him.

Roland Ames and his son, Shirley, are dressed in their best to take their well-behaved dog for a walk, around 1890. Roland, who was a carpenter by trade, spent most of his career at the Crosby boatyards. His and his first wife, Fanny Pullen, had two children, Shirley and Maud. After Fanny's death, Roland married Alice Jones of Sandwich.

When the schooner *Christina* crashed into the rocks off Cape Poge in Nantucket Sound on January 7, 1865, Charles S. Tallman, age 40, was the wreck's sole survivor. After spending four days standing on the deck in icy water, he was rescued, but his feet and several fingers were so badly frozen that they had to be amputated. He was forced to live the life of an invalid until his death 34 years later. The seaman was the son of Jonathan Tallman and Hannah Weaver Tallman and husband of Aurilla Cammett Tallman.

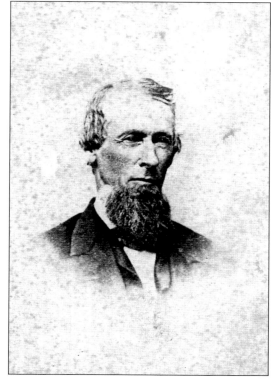

Capt. Oliver Coffin, who was born in 1812, is perhaps best remembered for marrying sisters. His first wife was Henrietta Boult, who died in 1844. In 1845, he married her sister, Martha. Both women were daughters of Charles Boult and Rebekah Lovell Boult. In his early years, the captain followed the whaling service and rose to become master of his own ship. While on a voyage to California, he and his brother, Joseph, decided to purchase a ferry berthed near San Francisco, and Oliver and his family left Cape Cod to settle there. After a few years, they returned to Osterville, and Oliver became a renovator of feather beds and hair mattresses.

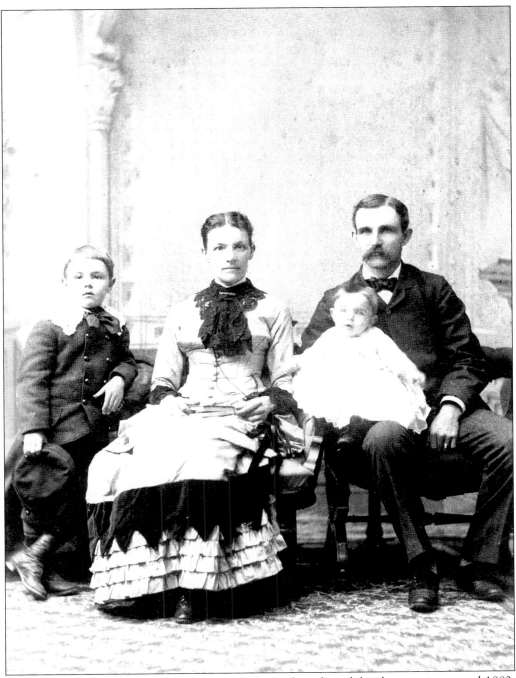

Charles F. Parker and Emma Matthews Parker pose for a formal family portrait, around 1882, with their sons, Henry and little Lovell. Charles operated a dry goods and grocery store in Osterville. Called a "wide-awake trader" who believed in keeping up with the times, he installed a horse trough near his establishment for the convenience of his customers. In 1885, he was elected town clerk and treasurer and later became a notary public. He also was part owner of an undertaking business but sold his interest to Samuel N. Ames in 1901.

Florence Adams Coleman sits for a family portrait around 1903, holding baby Irving with young Arthur by her side. She and her husband, Charles Coleman, later had a third son, Cecil. Florence was the daughter of John F. Adams, a local oysterman. Charles ran a trucking business in Osterville for many years, and his sons grew up to become his business partners.

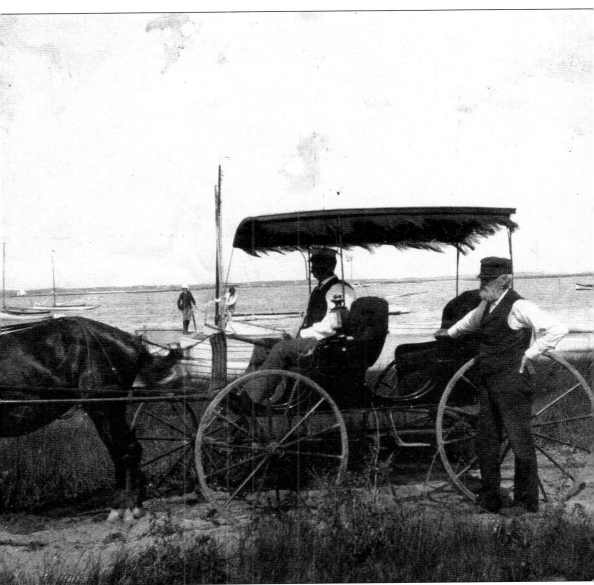

Capt. Jehiel Hodges instructs his son Henry in the fine art of driving a surrey across the sandy beach along East Bay. Though Henry lost a leg in a hunting accident in 1872, he recovered sufficiently to be able to join his brother Freeman in Florida where they operated a lumber business.

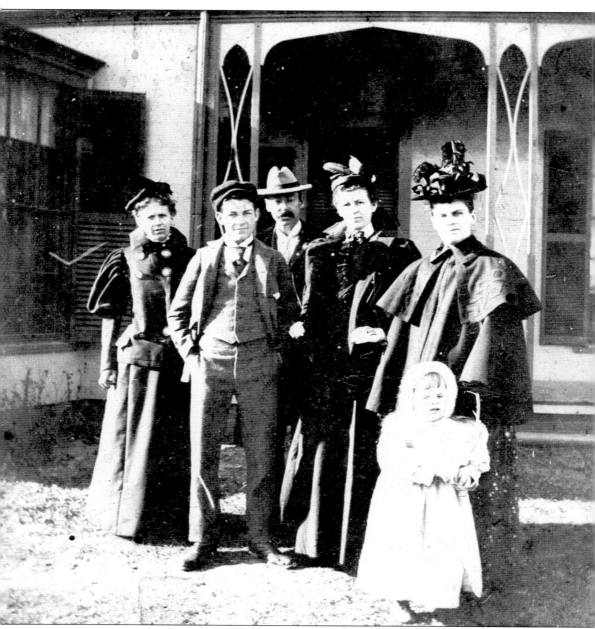

Carrie Rich Williams, Walter Fuller, Frank Williams, Olive Fuller, Florence Rich Chadwick, and young Karl Chadwick are seen from left to right gathered outside the old Seth Rich home in 1897 dressed for a Sunday outing. Carrie and her husband, Frank, had purchased her parents home in the heart of Osterville. Seth and Augusta Rich's three other children, Florence (pictured), Howard, and Walter visited frequently. Walter, who became an official in the U.S. Treasury Department, served as an alternate delegate to the National Republican Convention in St. Louis in 1896.

In 1877, Augusta Lovell Rich wrote a long and chatty letter to her sister Harriet Lovell Deane, who was living in Middleboro. Augusta's odyssey led Harriet through the village, street by street and house by house, painting a vivid picture of the families who had once lived there and describing those who had succeeded them. The tour continues down Main Street past Israel Crocker's dry goods store, the paint shop, the auction room, the milk room, Oak Shaw Crosby's ice cream shop, Village Hall, and on to Osterville's "Loafers' Pride", as she calls the post office. Augusta's letter, safely preserved, is now considered to be the definitive chronicle of Osterville life and lineage in the 1800s. The complete text can be found in Paul L. Chesbro's *Osterville: A History of the Village Volume II* and in *Osterville: A Walk Thru the Past* by Paul L. Chesbro and Chester A. Crosby III.

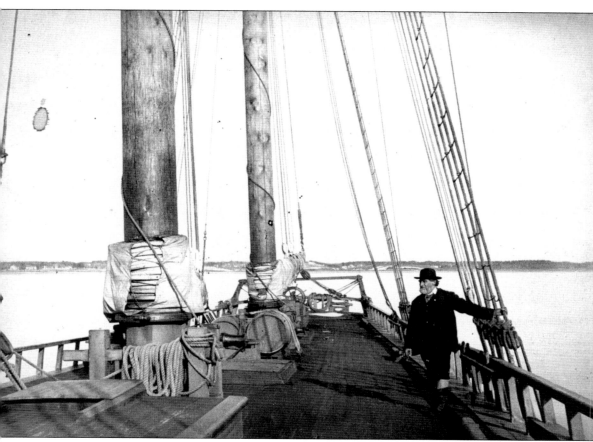

Capt. Nathan E. West Sr. surveys Osterville's East Bay from the deck of his command, the three-masted schooner *William L. Burroughs*. The ship was only the third of its design to be built in the United States and was proclaimed to be one of the fastest vessels in the coasting service, which worked the trade routes between Boston and New York and as far south as the Caribbean Islands. After he retired from the sea in 1887 at age 65, West piloted a passenger catboat around West Bay for the enjoyment of tourists.

Two

MAKING A LIVING

Many of Osterville's farmers, fishermen, sea captains, and tradesmen ran oyster-dredging businesses on the side. In 1895, the Tallman family had its oyster shanty on North Bay. The crew arrived before dawn to begin the grueling work, often having to break through the winter ice to get the job done. Then they hauled the oysters inside the shanty for culling, sorting, and packing into barrels. Taking a break, here from left to right, are (first row) Charles Crosby, Charles Hall, Edith Robbins Crosby, Jennie Hinckley Boult, Ernest Alley, and Minnie Cammett Allen; (second row) Wilton Crosby, Frank Boult, Myra Baker Crosby, Nathaniel Allen, Ella Lovell, Ida Bacon Hall, Azor Hall, and Stephen Tallman.

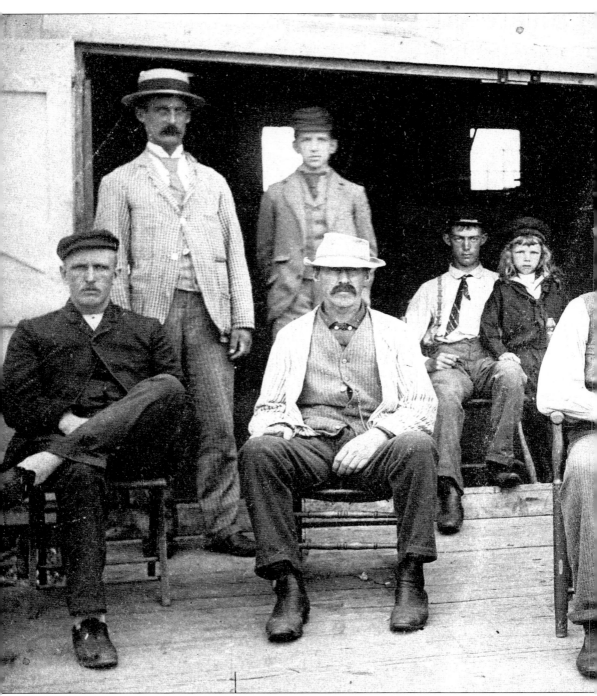

C. Worthington "Uncle Worthington" Crosby and some of his crew enjoy the warmth of a summer's day outside his boat shop around 1890. In the front row are J. Milton Leonard, Warren Lovell, Uncle Worthington, and Alexander Bacon. In the back row are Charles E. Lewis, Ralph Crosby, H. Manley Crosby, Harold Crosby, Oliver C. Coffin, Joseph C. Crosby, Billy Granger, Wilbur Crosby, and Charles A. Hall. The two boys in the back are unidentified.

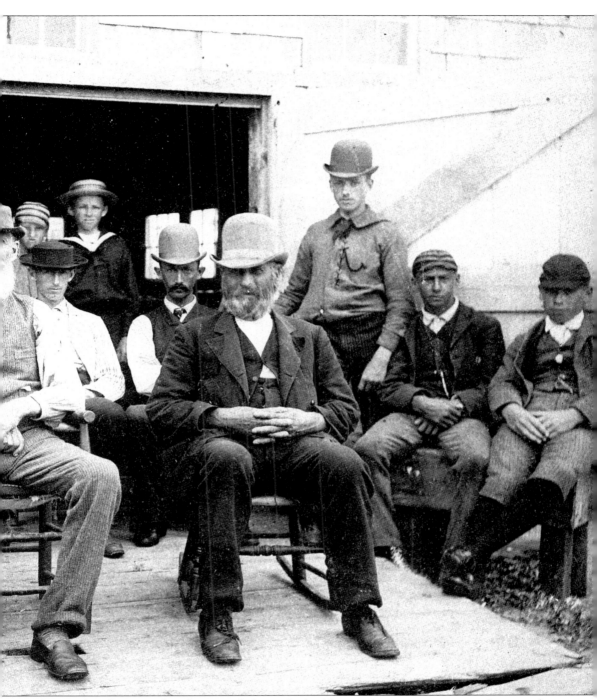

The Crosby clan owned and operated the yacht building and storage companies for several decades. The Crosby family began building boats in Osterville in the early 1800s, and in 1850, C. Worthington Crosby launched the first Cape Cod catboat. In 1892, former president Grover Cleveland, whose summer home, Gray Gables, was on Buzzards Bay, purchased one of their "cats" and named it *Grampus*.

Israel Crocker's Fancy Groceries and Meats began filling Osterville homemakers' shopping baskets in 1866, the year Israel purchased the store from Asa Crosby. Though he died in 1918, his store lived on under the proprietorship of his sons, Maurice, Milton, and Edward. Among the shoppers, around 1935, considering what to cook for Sunday dinner are Minnie Cammett Allen, Mabel Evans Robbins, Edith Robbins Crosby, Ruth Horne Jones, Jeannette Evans, and Clifford Jones. Clerk Adolph Crocker is behind the counter. Israel held the distinction of owning one of the first telephones in the village, one wire that connected his store with his home.

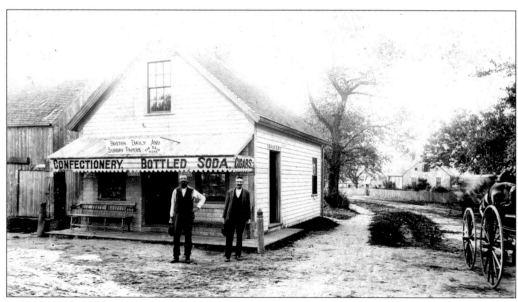

James Codd (left) and John Wesley Lewis trade stories in front of George H. Hinckley's confectionary and newspaper stand, around 1889. The store at the intersection of Parker Road and Bay Street was a popular gathering and gossip spot. It also served as a post office way station where the mail bound for Wianno was separated out.

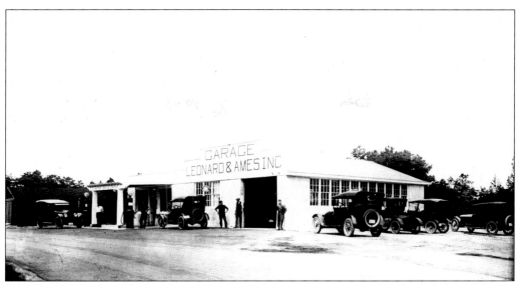

J. Milton Leonard and Bernard Ames combined their entrepreneurial skills with hard labor in the early 1900s to open and maintain one of Osterville's first automobile repair shops and gas stations. Part of the garage, located at the corner of Main Street and Pond Street, was reserved for repairing bicycles, and another section was used for building wagons and blacksmithing. Bernard also was chief engineer for the local fire department. In addition, the two men ran a transfer service between the West Barnstable train station and Osterville that promised patrons "a high grade automobile with a careful man in charge."

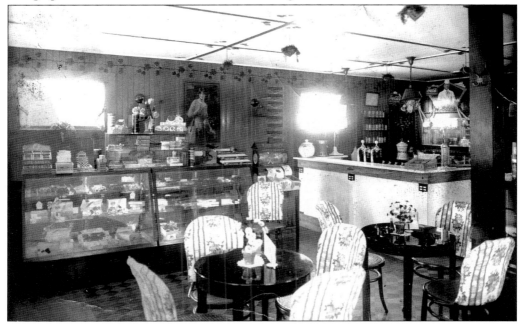

The Horne of Plenty, Osterville's place to be seen in the 1930s, was the classiest ice-cream shop and lunch room in town. The shop opened in 1929 on Wianno Avenue. The proprietor and hostess was Ruth Horne, who later married Clifford Jones, and whose mother was the former Edna Crosby.

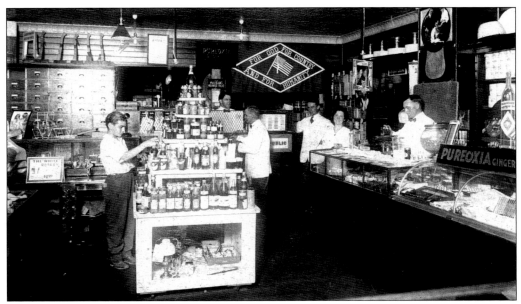

In 1913, Walter Fuller operated a small store on Main Street. Before long, his business expanded into a full grocery market. In 1916, Walter won a trip to Washington D.C. from Perry Doge & Company for selling 1,000 pounds of its tea and coffee in less than one year. Here, around 1915, Arthur Coleman checks out the stock in the display of juices. Fuller is behind the counter talking to Charles Jones. The people on the right are identified as "not Osterville folk."

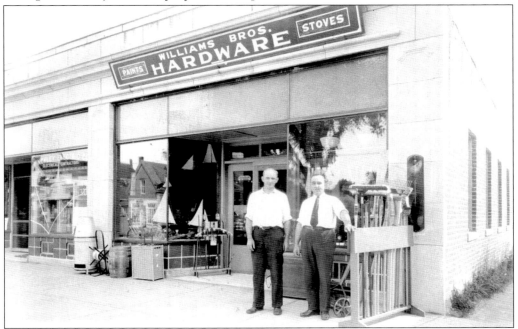

William Brothers Hardware store in the Pattison block on Main Street, around 1920, featured paint, stoves, brooms, hoses, and even miniature sailboats. The brothers in the store were Ralph and Norman, sons of John H. Williams Jr. and Bessie Savery Williams. Here Norman (left) discusses a sale with a customer.

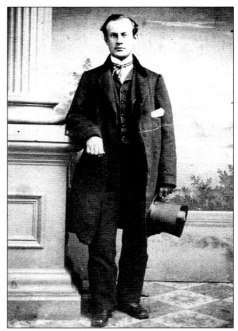

In the late 1800s, attorney Franklyn Hallett Lovell (left) co-owned a lighting appliances and fixtures company in New Jersey with his brother Capt. Orville D. Lovell (right). The business flourished worldwide, and the two retired with personal fortunes. In 1881, the brothers presented the Cotocheset House with four beautiful lamps for its parlor. Orville and his wife, Augusta Bearse Lovell, built a magnificent "cottage" on The Bluffs above Nantucket Sound. When Orville died in 1923, he left an estate of $68,062.70, considered an immense legacy for the time. An animal lover all his life, he had his three dogs, Daniel, Daniel II, and Pilot, interred in Osterville's Hillside Cemetery and personally composed the poems for their headstones.

Horace Scudder Parker's grocery store stood next to the Methodist Episcopal Church on Main Street. When he purchased the business in 1891, it was in a much smaller building that had belonged to the late G. H. Hinckley. Horace soon expanded his stock, changed the name to H. S. Parker & Company, and, in 1895, moved the business into this new building. In 1904, he married Lillian Suthergreen. She was the daughter of Wesley Suthergreen Sr., who was lost at sea in 1881 aboard a ship bound for the British West Indies.

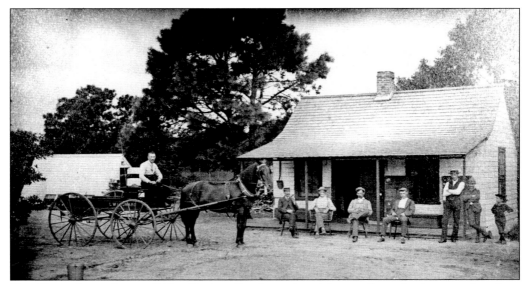

Hen Town, located just off Fire Station Road, got its nickname from the large poultry farm operated there by L. Willis Leonard, around 1890. Here, Stillman Spinney drives up in his wagon to pass the time with his friends. Among those waiting to greet him are Roland Ames, L. Willis, Charles Lewis, Henry P. Leonard, and Shirley Ames.

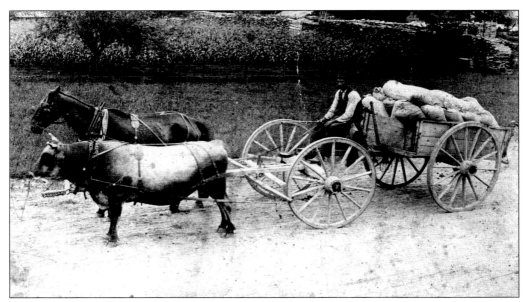

Walter Lewis is off to the hay scales around 1885, driving his "odd couple" team of one horse and one ox. Walter added to his income from farming by repairing shoes and building houses. He constructed a fine Cape Cod home on Parker Road for his wife, the former Mary Elliott of Boston, and their four children.

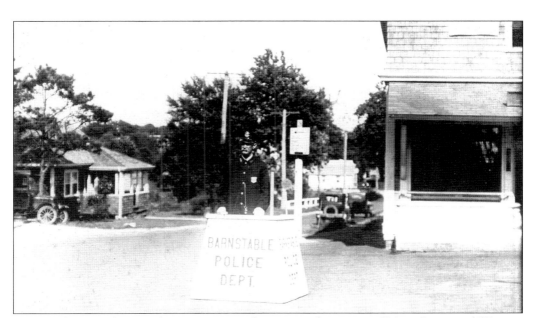

Officer Chester Baker stands at attention at his post at the corner of Main Street and Wianno Avenue around 1925. A tinsmith by trade, he also served for 20 years as a police and traffic officer in Osterville, and for 13 summers, he tended the bridge connecting the mainland with Little Island and Oyster Harbors.

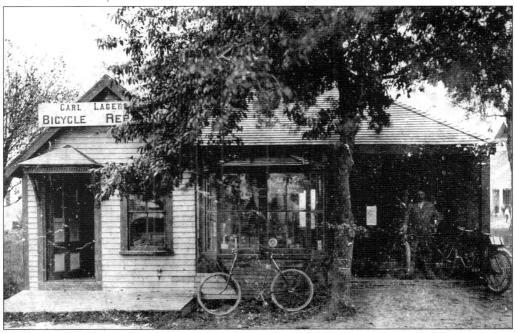

Around 1900, Carl Lagergren picked a cool spot on Main Street to open a bicycle repair shop. At the right, Carl can be seen standing in the shaded doorway. He and his wife, Emily, had come to Osterville from Sweden separately in the late 1800s and married once they got to Cape Cod. When automobiles became more numerous than bicycles, Carl converted his business to a garage, repair shop, and service station.

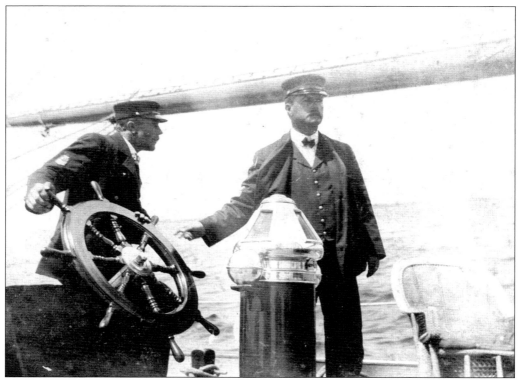

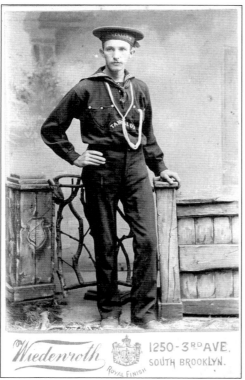

In the late 1800s, Capt. Nathan E. West Jr. followed his father into the seafaring life. Here, he gives orders to his helmsman aboard the yacht *Marguerite*. The captain spent much of his career ferrying yachts up and down the East Coast for their wealthy owners. When home between voyages, he sang in the choir at the Baptist Church and often played the organ there. His wife, Sara Adams West, served as Wianno's postmistress during the summer season when the captain was at his busiest. Shown at left, a young Nathan West Jr. stops to have his picture taken during shore leave in Brooklyn, New York.

Wiedenroth
1250 - 3RD AVE.
SOUTH BROOKLYN.
ROYAL FINISH

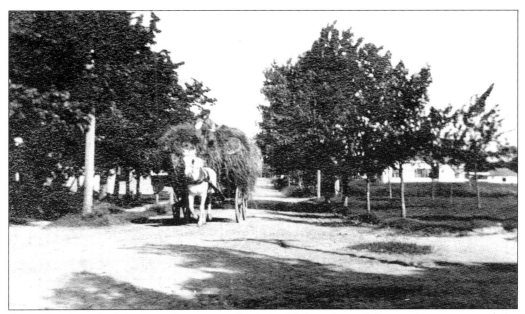

A sturdy white draft horse pulls a wagon loaded with hay down Wianno Avenue toward the village green where it would be weighed at the hay scales. Local residents also used the scales to measure their grain, ice, and even coal. The scale consisted of a plank platform laid across an iron mechanism. In turn, each farmer would back his loaded cart onto the platform, and the official town "weigher" would record the heft before the load was put up for sale.

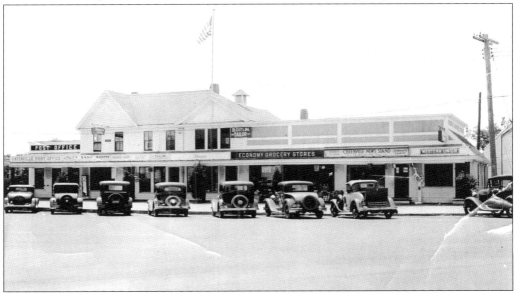

Parking space was at a premium in the 1930s in Osterville's central business district. With one stop, patrons could visit the post office, Burlingame's Barber Shop, Osterville Electric, E. E. Gray Company, Western Union, Osterville Tailoring, and the Osterville News Stand. The strip of prosperous businesses was known as the Daniel Block, developed by builders Charles and Robert Daniel, who were considered newcomers to the village. They moved to Osterville from Great Britain in 1879.

Henry Cammett stands in the doorway of his blacksmith shop around 1885, waiting for a customer. The shop stood at the corner of Timothy Parker's Place and Bay Street. Henry led a quiet, retiring village life, but his sister Minnie Cammett Allen craved excitement. In the early 1900s, Minnie became the first lady from Osterville to go through the newly opened Cape Cod Canal, traveling from Boston to New York by ship. She also was one of the first women to sail through the Wianno Cut at Dead Neck, which finally connected West Bay with Nantucket Sound.

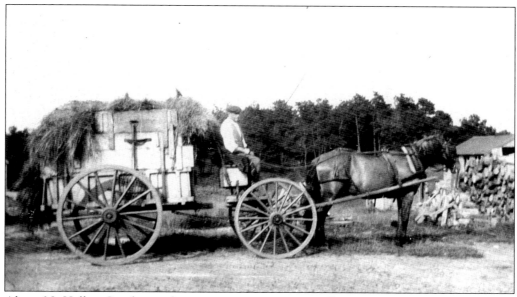

Alcott N. Hallett Sr., driving his tipcart, prepares to set off on morning deliveries. The year was 1925. Hallett also ran the village's livery and teaming services and regularly hauled barrels of oysters to the train station in West Barnstable. In the winter, he delivered ice (cut from neighboring ponds) to the village's many icehouses. In his younger days, he often went to sea as a crew member of the schooner *Balsora L. Sherman*.

Three

JUST FOR FUN

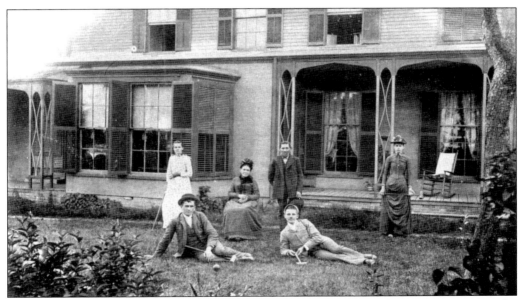

The Seth Rich family, around 1890, takes time out from a hard-fought croquet game on the front lawn of their Main Street home. Seen from left to right in the back row are Florence Rich Chadwick, Augusta Lovell Rich, Seth Rich, and Carrie Rich Williams. Sons Howard and Walter stretch out on the grass.

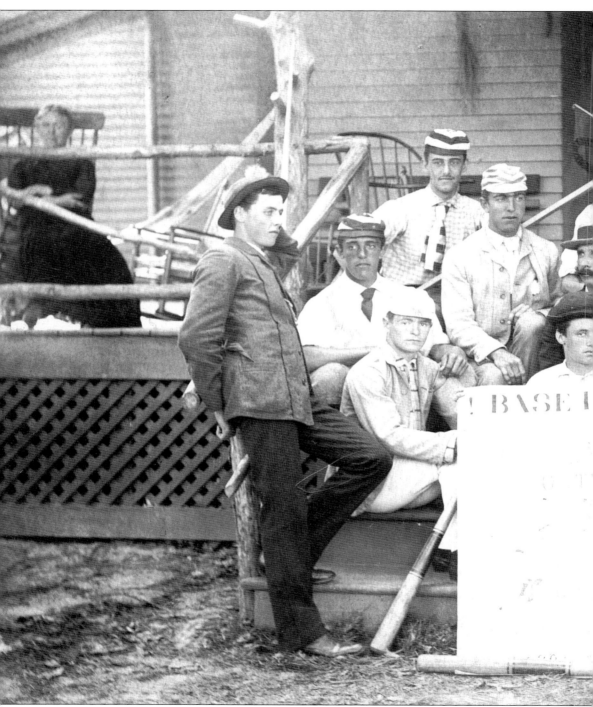

Osterville's baseball team of 1886 takes time out from practice to rest on the steps of the Hallowell cottage. From left to right are (first row) Mr. Chapman, J. Austin, Frank Hallowell, Mr. McPherson, and A. Merrill; (second row) unidentified, Mr. Rivers, Mr. Holland, and C. E. Loud; (third row) J. Mott Hallowell, W. Austin, Bradford Ames, J. P. Loud, and Fred Mead.

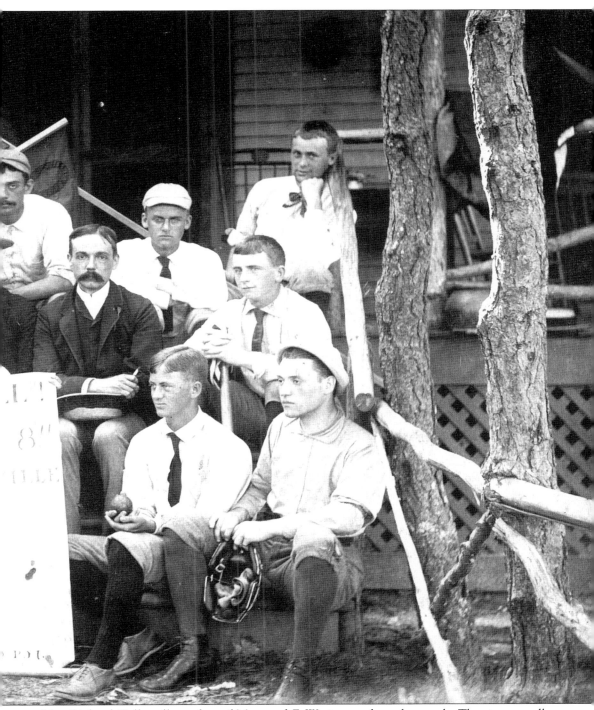

Mrs. Richard Hallowell, mother of Mott and F. W., is seated on the porch. The sign proudly proclaims: "The nine that never lost a game. You have done noble." (Frank Hallowell went on to play baseball for Harvard College.)

Thespian and lecturer Barney Gould wandered into Osterville on occasion to regale his audiences with tales of his travels to nearly every state in the union, or so he said. In 1874, he entertained a capacity crowd at Village Hall by expounding on women's rights and religion as well, and then, it is said, he "tripped a bit of the light fantastic." The evenings apparently were a huge success. A member of the audience reported that "altho' a large company of young people were present, the attendance of even a single justice of the peace was not required to preserve order."

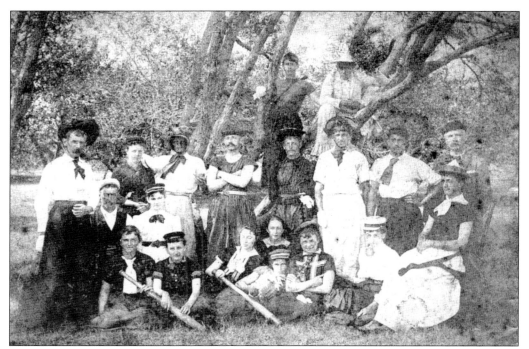

The Osterville Baseball Club, around 1893, took time out from serious competition to dress up like anything but baseball players. None of the masqueraders are identified, nor did they want to be.

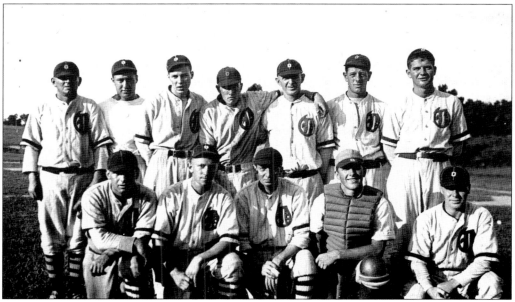

In 1932, Osterville's Twilight Baseball Club took home the second-half season championship in the Cape Cod Twilight League by winning nine games and losing only three. Kneeling from left to right are Tony Campana, A. L. Crocker, Mr. Wadlin, G. Cross, and Irv Coleman. Standing are F. Bearse, H. Coombs, Howard "Pop" Sears, Perkins "Perk" Evans, N. Williams, Red Lane, and Leo Shields.

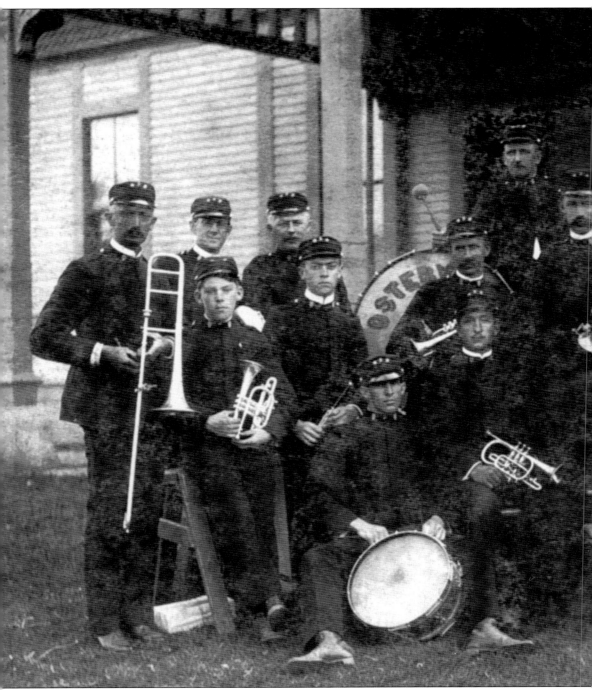

Osterville's Silver Band lines up, around 1905, for a formal photograph. Pictured are Joseph C. Crosby, G. Webser Hallett, Edward Crocker, J. Milton Leonard, Abbott Robbins, John Horne, George Williams, Frederic Scudder, Harold Crosby, Edmund Lewis, H. Manley Crosby, Carl Lagergren, Owen Lewis, George Ford, Nathan West Jr., Frank Williams, Edmund Fuller, Helge Lagergren, Burleigh Leonard, Stephen Bates, and Willis Crocker. The young men of Osterville

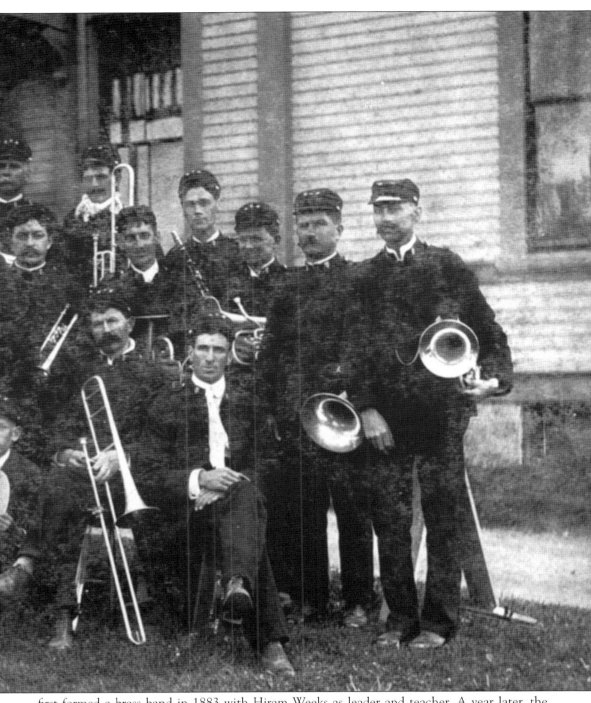

first formed a brass band in 1883 with Hiram Weeks as leader and teacher. A year later, the musicians changed the name to the Excelsior Brass Band. In 1902, it became the 21-piece Silver Band, which gave regular concerts throughout the village and performed at parades, parties, and dances across Cape Cod well into the 1940s.

Frank Williams prepares for a rousing game of ball with his little dog on the banks of the Centerville River. In 1899, Frank married Carrie Rich, and the couple moved into the Rich homestead on Main Street in 1904. Frank was the proprietor of the Star Theater, which specialized in showing silent movies. During the summer, Carrie operated an ice-cream parlor on the property. In the background is the Hinkle Bridge, which spanned the river and crossed over to Long Beach. It was built around 1907 and named for Charles M. Hinkle, a summer resident who maintained a mansion on The Bluffs. The bridge was dismantled in 1974.

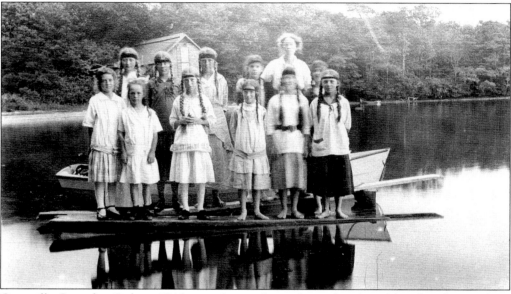

Osterville Campfire Girls in 1916, complete with regulation braids and headbands, are about to embark on a row to the end of the lake. They are from left to right (first row) unidentified, Imogene Leonard, Mildred Lewis, unidentified, Edna Suthergreen, and Olive Scudder; (second row) Margerie Leonard, Agatha Crocker, Helen Whiteley, Elsie Chadwick, Genieve Leonard, and Annie Nute. Village girls also had the opportunity to become Girl Scouts, and the Red Rose Troop published a cookbook to raise spending money.

Two Osterville families are out for Sunday strolls around 1910. A mother and her two children take time out from their walk to rest at Bridge Street Beach and enjoy the cool breeze blowing off West Bay. Below, as Grandma watches, Grandpa teaches his little granddaughter how to fish for crabs off the old coal dock at the foot of Bay Street. Across the water is Little Island.

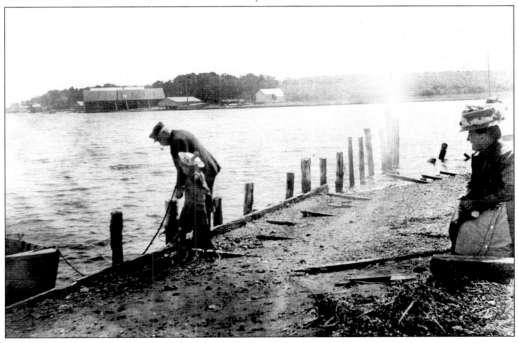

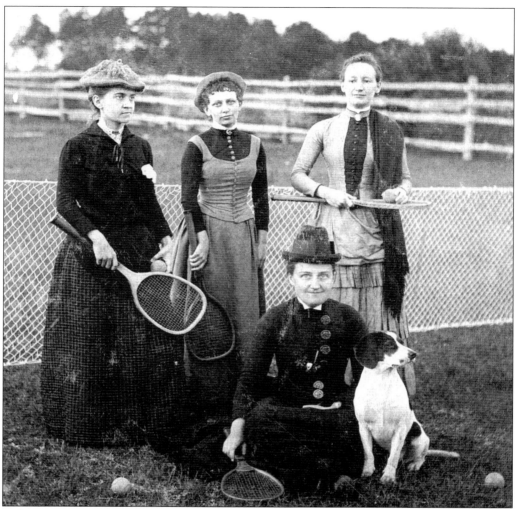

A foursome for ladies' tennis in 1888 was made up of Sarah Boult (left), Mary Lovell Crocker (standing center), Lizzie Small, and Jennie Hinckley Boult (seated). Two of the friends married; two never did. In 1901, Sarah traveled to Boston to study dressmaking, but when she returned to Osterville in 1906 she took the job of Wianno's summer postmistress and later worked for the Hyannis Trust Company. She and Jennie became sisters-in-law. (Jennie married Frank Boult in 1892.) Mary married Maurice Crocker in 1896. Lizzie studied bookkeeping and stenography and worked in Boston for many years.

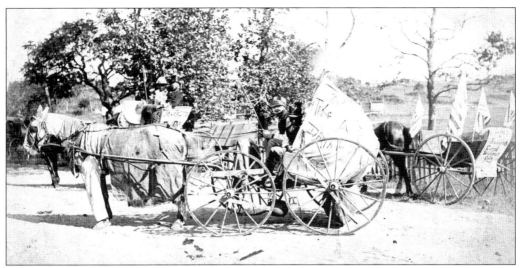

Homemade floats for the "Antiques and Horribles" parade line up to join in the Osterville Fourth of July celebration around 1890. Even the horses wore costumes for the annual event, which was the village's most festive celebration of the year. In the line of march were an antique stagecoach filled with clowns and "other grotesque characters" including Merry Widows. Village boys were allowed to ring the church bells for an hour beginning at noon, and the day ended with fireworks and music by the Osterville Band.

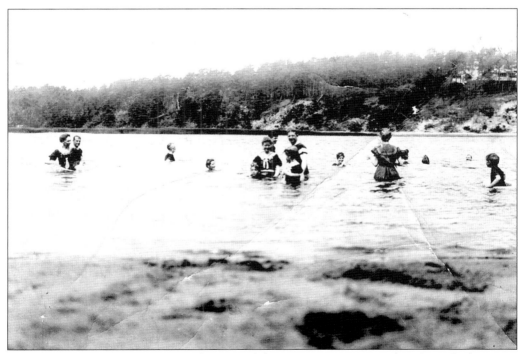

Village families plunge into the cool waters of the Cotuit Narrows on a hot Cape Cod summer day around 1900. Across the inlet is Cotuit Highlands.

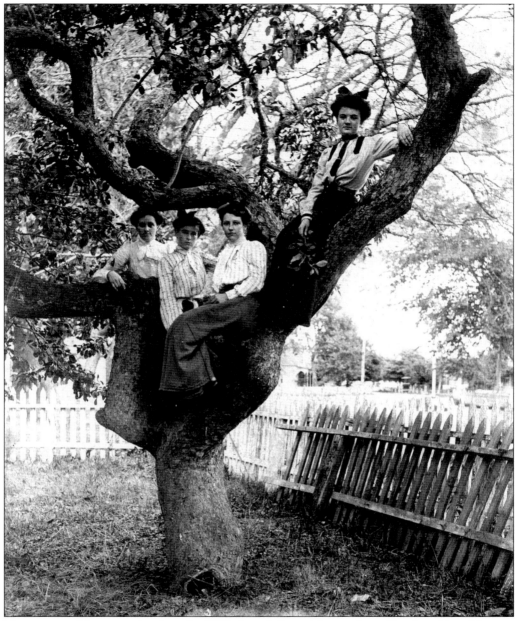

Up a tree and happy to be there in 1907, from left to right are Lucy Crocker, Mary Norton, Gertrude Adams, and Mabel Keyoe. Mary and Gertrude had known each other since their days at the Dry Swamp Academy. Lucy later married George Rankin, a native Nova Scotian who came to Osterville to work as a mason. The couple eventually settled down on the old Clarington Crocker farm on Pond Street, which had been Lucy's parents' home.

Four

LANDMARKS

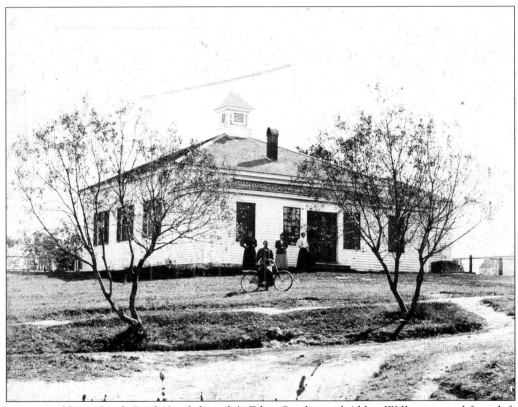

Fannie Robbins, Sarah Boult (with bicycle), Edna Crosby, and Abbie Williams stand from left to right in front of Village Hall, which served Osterville for many years as a school, public meetinghouse, and church. It was in this hall in 1815, during a celebration to mark the end of the War of 1812, that the townspeople decided to change the name of the village from Oysterville to Osterville.

Old Village Hall, which stood at the intersection of Main Street and West Bay Road, was taken down in 1897 to make way for Union Hall, which opened in April 1898. Standing in the snow are Emily Fuller, wife of Herschel Fuller who was chairman of the trustees, and N. H. Allen, the building's architect. The new community center became the favored location for masquerade balls, theatrical events, and concerts sponsored by local clubs and associations. In 1917, it was wired for electric lights. In the late 1930s, the building was taken over by the local horticultural society. After World War II, it became the home of the Osterville Veterans Association.

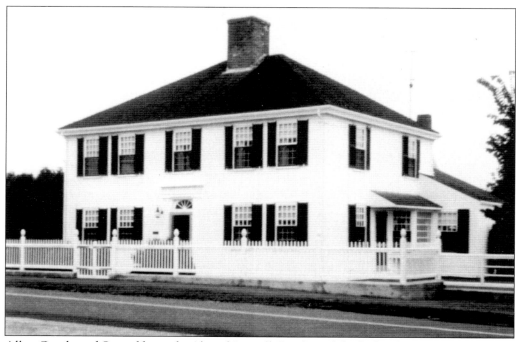

Allen Goodspeed Sr. and his wife, Abigail Linnell Goodspeed, built this dignified, no-nonsense home in 1795, the year their first child, Seth, was born. Seth grew up to become a master shipbuilder and salt manufacturer on East Bay. In 1838, he was elected to the Massachusetts state legislature.

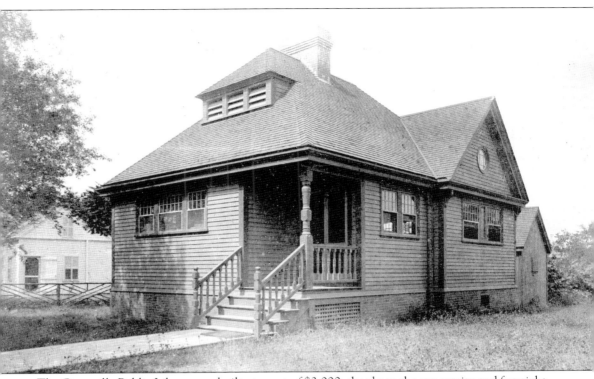

The Osterville Public Library was built at a cost of $3,000, thanks to the generosity and foresight of abolitionist William Lloyd Garrison, a Wianno summer resident who organized a village-wide subscription drive. The building and its Queen Anne–style furnishings were declared "neat, substantial, and beautiful" at the building's dedication in the Methodist Episcopal Church on January 18, 1882. The first librarian to serve in the new building was the Rev. E. B. Hinckley, whose salary was set at $200 per year.

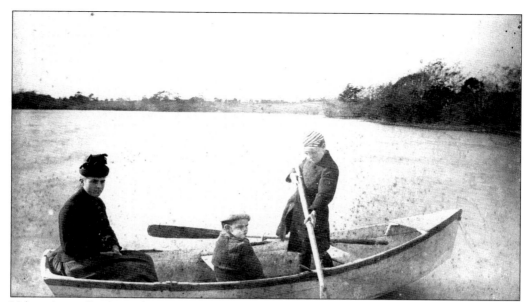

Velina Ames Crosby and two young crew members shove off from shore for a row across Aunt Tempy's Pond about 1890. Aunt Tempy (Temperance Crocker Parker) was Velina's grandmother.

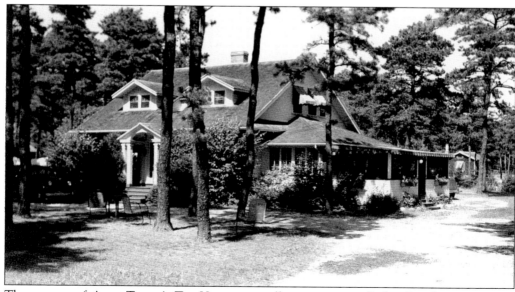

The owners of Aunt Tempy's Tea House, a small restaurant on Parker Road around 1940, chose to honor one of the neighborhood's earliest residents when they selected a name for their establishment.

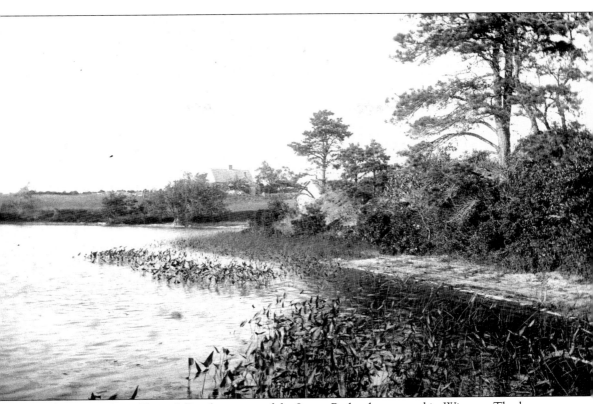

In the 1800s, Aunt Tempy's Pond was part of the James Parker homestead in Wianno. The large Parker house can be seen in the background. Rimmed with reeds and lilies, the pond was located just off Parker Road. The area is now part of the Wianno Golf Club's first fairway.

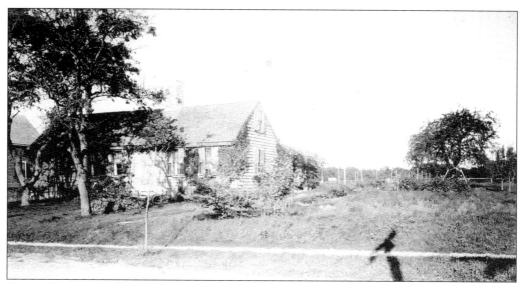

No one knows who first lived in this small but sturdy house built in the mid-1700s, but records indicate that Capt. John Cammett and Elizabeth Hawes Cammett, who married in 1808, are among its earliest known residents. They raised four children here. In 1830, the house grew to twice its size when the kitchen and parlor were added. Occupied by many families over the years, including Isaac Lovell and Mercy Crocker Lovell, the Cammett House was moved in 1981 from 914 Main Street to the site of the Osterville Historical Society. Now restored and refurbished, it is open for tours during the summer and fall.

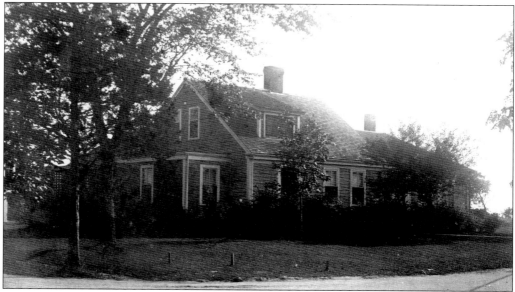

The Capt. Jonathan Parker house, built in 1824, is now the headquarters of the Osterville Historical Society. Visitors are invited to tour the dignified old two-story home, which is furnished with antiques representative of the era when Osterville captains and their schooners dominated the coastal trading from Boston to the Caribbean Sea. The sea captain's son, William Parker, probably was born here in 1836. Like his father, he went to sea early on and rose to the rank of captain.

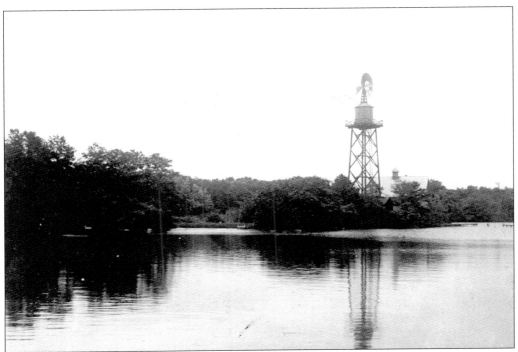

The windmill and water tower that rose above serene Crystal Pond stood there long before it became a much sought after place to build a home. The little lake is located in the center of the Wianno area of the village.

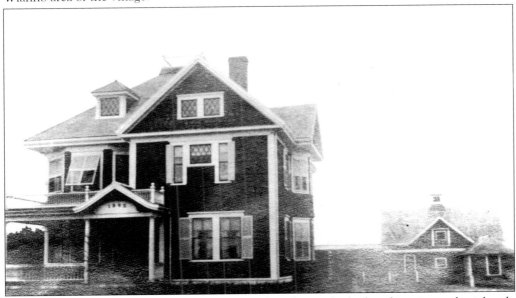

Capt. Henry Foster Lewis and his wife, Cora Adams Lewis, built this charming, colonial-style home on Main Street in 1905. After spending 22 years at sea, the captain settled down ashore and became a carpenter. He also worked as a stagecoach driver and a male nurse. The house, called "one of the largest and finest in the village," burned to the ground on January 31, 1921. Little could be saved because the intense winter cold had frozen much of the firefighting equipment.

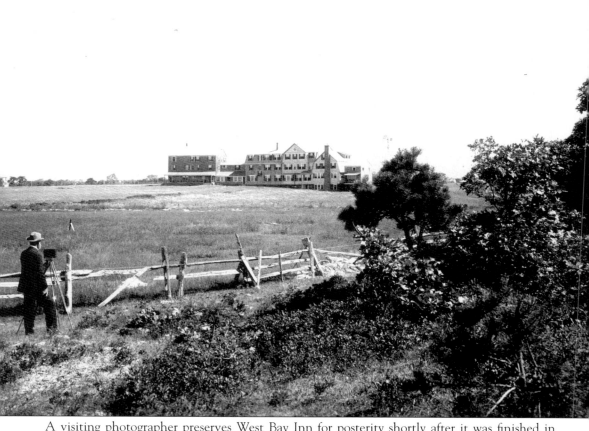

A visiting photographer preserves West Bay Inn for posterity shortly after it was finished in 1906. Located at the beginning of Eel River Road, the inn was built by Edward S. Crocker and had a breathtaking view of Nantucket Sound. It was also said that its 65 rooms offered guests the coolest spot in Osterville. On October 17, 1935, while it was unoccupied and up for sale, the inn burned down in one of the most spectacular fires that Osterville had ever experienced. It was said that thousands of people turned out to watch.

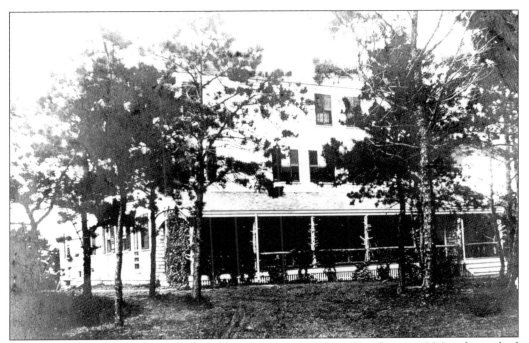

Squirrel Inn, a guesthouse on Wianno Avenue, was moved to West Bay in 1906 and attached to West Bay Inn after Henry Leonard bought the property so he could build a home there. Originally, the house belonged to Frank Boult, who built it in 1889.

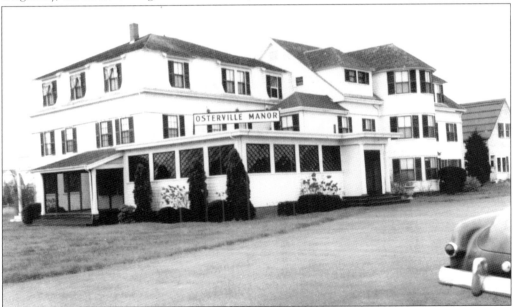

In 1860, Horace Crosby and his wife, Lucy, expanded and refurbished their West Bay home into an inn that could accommodate as many as 70 summer boarders. They called it The Crosby House. In later years, a Crosby grandson Harold managed the property. In 1927, the Crosby family sold it to Leonard Bliss of Pinehurst, North Carolina. Several years later, it became known as Osterville Manor.

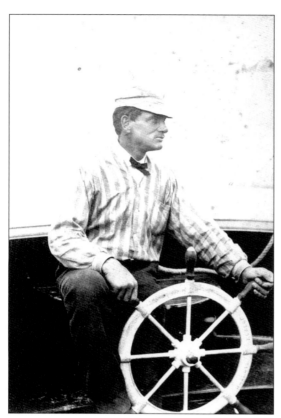

Osterville's intrepid Capt. Nelson Bearse Jr., here at the helm of his schooner *Nelson Harvey*, was most proud of the day in 1872 when he and his crew rescued all hands aboard the sinking schooner *Virginia* during extremely heavy weather off Chatham Light. After spending many years commanding ships in the coastal trade, he and his wife , Mary Ames Bearse, turned their large, elegant home into a tourist hotel and called it East Bay Lodge. The couple operated the inn for 28 years. Below is the house in 1890 before they embarked on a major project to build a substantial addition that would accommodate more guests and staff.

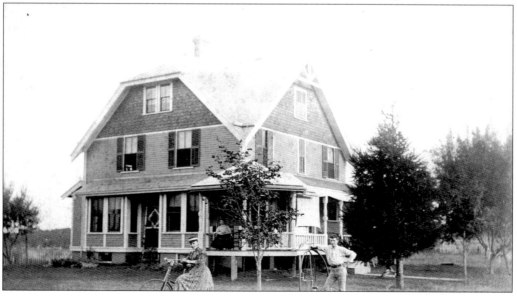

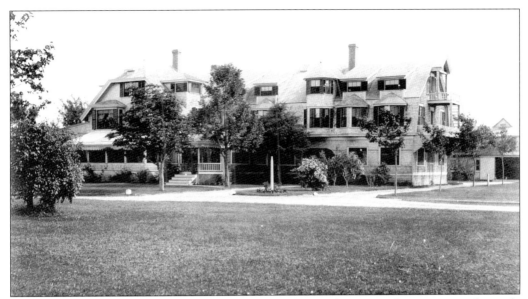

East Bay Lodge dominated Osterville's seaside landscape during its glory years in the early 1900s. On a sunlit summer day, the view from the tree-lined driveway next to the lodge was magnificent. Visitors called it one of the choicest resorts on the New England shore. (In 1904, a sumptuous Sunday dinner cost 75¢.) The lodge changed hands several times over the years and finally closed in the 1990s and was torn down.

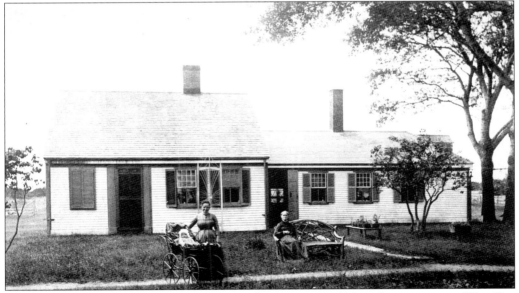

The Josiah Ames homestead on East Bay Road gave way in 1900 to the expansion of East Bay Lodge. The house was turned around on its foundation, and an annex was built over the old structure. Here, in a photograph taken just one year earlier, Henrietta Ames Chadwick tends to her son Philip Chadwick in the baby carriage. Henrietta's mother, Harriet Ames, relaxes in a wicker chair. Henrietta was married to Capt. Joseph Chadwick, who followed the coastal trade for many years, and the younger family also had a home on East Bay. After retiring from the seagoing life, Joseph became a carpenter.

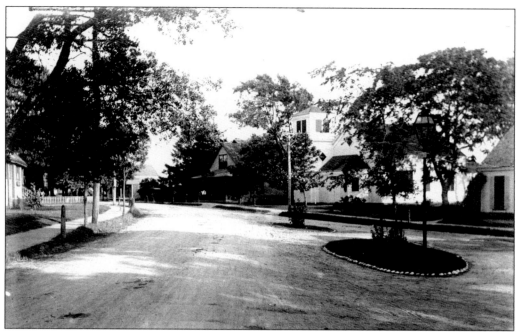

With its miniature village green, the intersection of Main Street and Parker Road is a landmark that has changed very little over the past century. Although the old Methodist Episcopal Church, Parker's Dry Goods and Small Wares Store, and the old Osterville Public Library have given way to more modern and sophisticated shops and public buildings, the spirit of these long-gone village institutions lives on. Below, the family dog waits to welcome the James A. Lovell family back to their home, another landmark, which stood at the intersection of West Bay Road and Wianno Avenue.

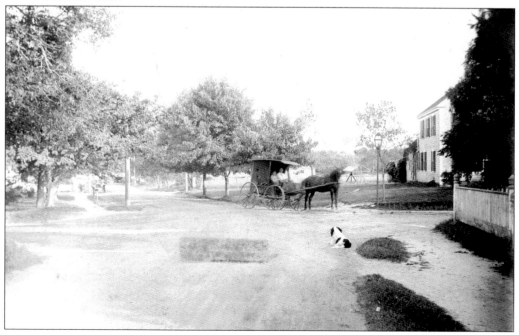

Five

READING, WRITING, AND RELIGION

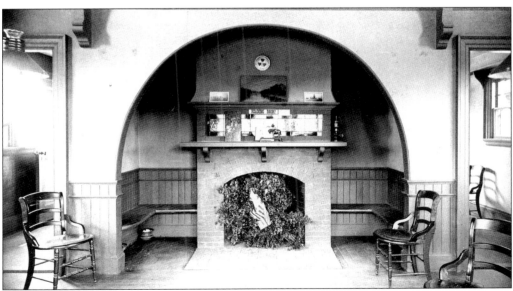

In 1881, the fireplace in Osterville's new library in the heart of Osterville Center was all decked out in evergreen branches in celebration of the library's first Christmas. Founded in 1873, it had never had a building to call its own until a Wianno summer resident, abolitionist William Lloyd Garrison, led a campaign to raise funds for its construction.

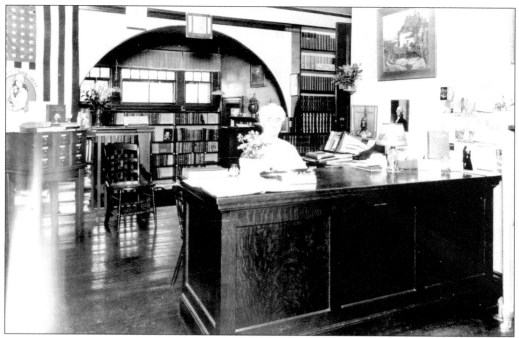

Osterville librarian Katherine Hinckley presided over the front desk for 37 years, 1917 to 1956. Born in 1877, she was 79 when she finally retired from her post, and she died five years later in 1961. As she grew older, Katherine liked to remember that it was during her first year on the job that the building was wired for electric lights. Among her other interests was the Hillside Cemetery Association where she served as president. Left, soon after she took charge of the village library, Katherine journeyed all the way to New York City to have this portrait taken.

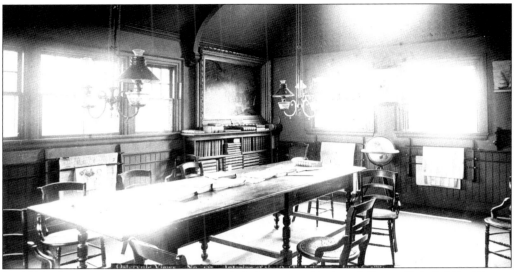

In 1894, the main reading room personified the quiet dignity of Osterville's Public Library, although it would be 23 years before Katherine Hinckley took charge. The desire to have a real library grew out of the Osterville Literary Society, founded in 1878, when its early members pledged themselves to "sing, declaim, read, etc. for general improvement."

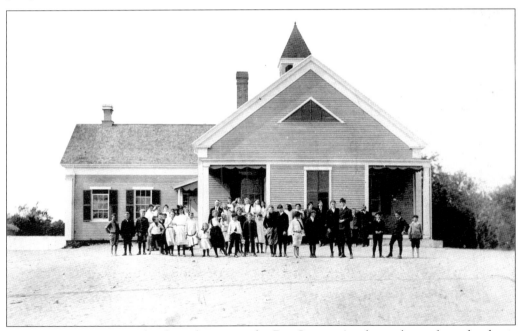

Osterville's elementary school was known as the Dry Swamp Academy almost from the day it opened in the 1860s. Located on Main Street behind the Baptist Church, it was surrounded by swampland. Here, the class and faculty of 1907 pose for the photographer. During the fall cranberry-picking season, schools closed down so the students could help with the harvesting. When a new school was constructed in 1914, the Dry Swamp Academy became the village community center. Both buildings eventually fell to the flames, the new school in 1914 soon after it was completed and the community center in 1979.

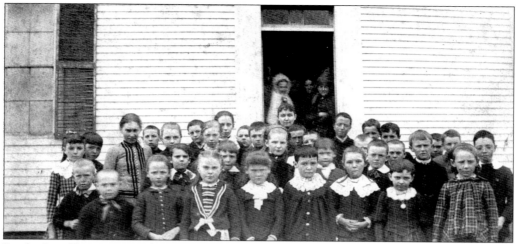

Bertha Lovell's primary students of 1888 at the Dry Swamp Academy grimly await the taking of their class picture. The class roll is incomplete, but those included are Warren Hodges, James Horne, Nellie Crowell, Florence Adams, May Weeks, Georgina Daniel, Jennie Baker, Edna Crosby, Gertrude Adams, Mabel Jones, Katherine Daniel, Emily Crocker, Louise Adams, Myrtle Crosby, Thomas Horne, Harry Tallman, Robert Daniel, Charles Hall, Blanche Lovell, John Horne, Etta Lovell, Jennie Fuller, Henry Parker, Charles Coleman, Herbert Crosby, Charles Daniel, Lester Lovell, Roy Crocker, Everett Fuller, and Augustus Coleman. Two of the mothers in the doorway are Eunice Fuller and Emily Fuller Crosby.

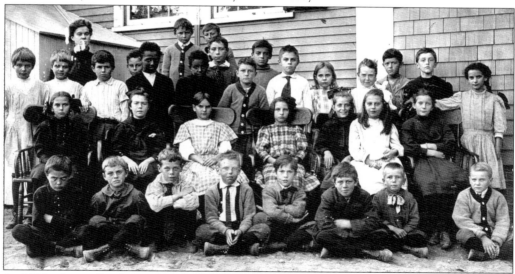

In 1908, Osterville Grammar School's fourth, fifth, and sixth grade students sat for their formal portrait. Pictured here from left to right are (first row) Wilton Crosby, Ralph Williams, Lincoln Baker, Wilson Scudder, George Berry, Bill Rulon, Albert Adams, and Eldon McCabe; (second row) Hazel Ames, Annie Laurie Crosby, Sarah Alley, Loraine Ames, Alma Crosby, Verna Patterson, Hester Bell, and Isabel Lewis (standing); (third row) Emily Crosby, Josephine Crosby, Merton Bates, John Gomes, Peter Gomes, Edwin Lagergren, Hallett Boult, Jessie Boult, Margaret Cross, Philip Barnet, and Victor Adams; (fourth row) teacher Olivia Phinney, Walcott Ames, Elmer Taylor, Bertel Lagergren, Thomas Hansberry, and Maurice Allen. In addition to her teaching duties, Phinney also served as secretary of the Osterville Improvement Committee.

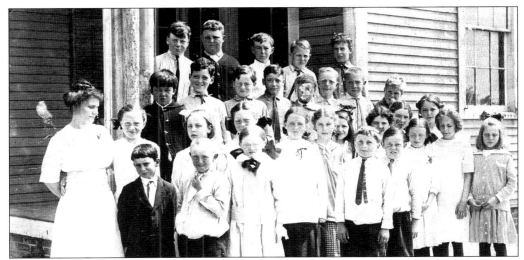

Cora Nicol (front left) taught fourth-, fifth-, and sixth-grade students at the Dry Swamp Academy in 1914. Standing for their class picture from left to right are (first row) Nicol, Howard Lewis, Elmer Whiteley, Ruth Horne, Carleton Small, Alfred Lagergren, Jessie Lewis, Grace Crocker, and Dorothy Cahoon; (second row) Edith Cahoon, Ethel Parker, May Cahoon, Ethel MacDonald, Charlotte Boult, Mary Shields, Louise Adams, and Eleanor Taylor; (third row) Leslie Nute, John Shields, Kenneth Jones, Humphrey Manix, Irving Coleman, Clifford Jones, Chester Crosby, and Kenneth Lovell; (fourth row) Mansfield Crocker, George Thurber, Ralph Hinckley, Merrill Crosby, and Truman Lewis.

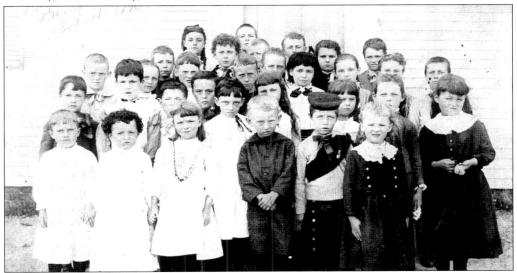

Just 32 children were enrolled in Osterville Primary School (grades one though six) in 1890. Only 11 were boys. Pictured here from left to right are (first row) Bertha Chadwick, Teresa Daniel, Hannah Lewis, William Hodges, Lovell Parker (in kilt), and Mary Hinckley; (second row) Frank Crosby, unidentified, Margaret Daniel, Edna Crosby, unidentified, Josephine Crocker, Agness Till, and Elizabeth Coleman; (third row) Ariel Tallman, Nellie Crowell, Oscar Johnson, May Weeks, James Horne, Warren Hodges, Georgiana Daniel, Jennie Baker, Florence Adams, and Augustus Coleman; (fourth row) Mabel Jones, unidentified, Henry Parker, Lester Lovell, Mabel Evans, Albert Hinckley, Louise Adams, and Charles Coleman.

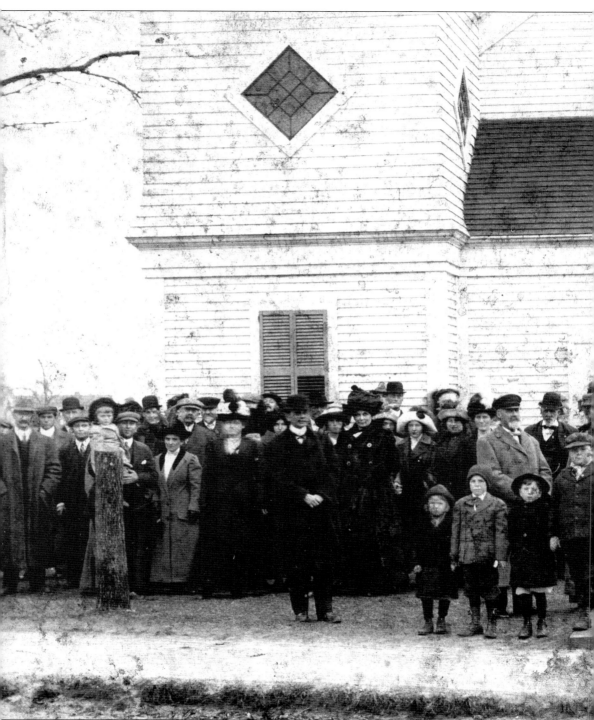

In 1913, nearly 75 townspeople took part in the Big Sing, staged in celebration of Christmas by the Methodist Episcopal Church and the Baptist Church in front of the Methodist sanctuary. The Methodist church, established in 1847 and located in the center of the village near the hay

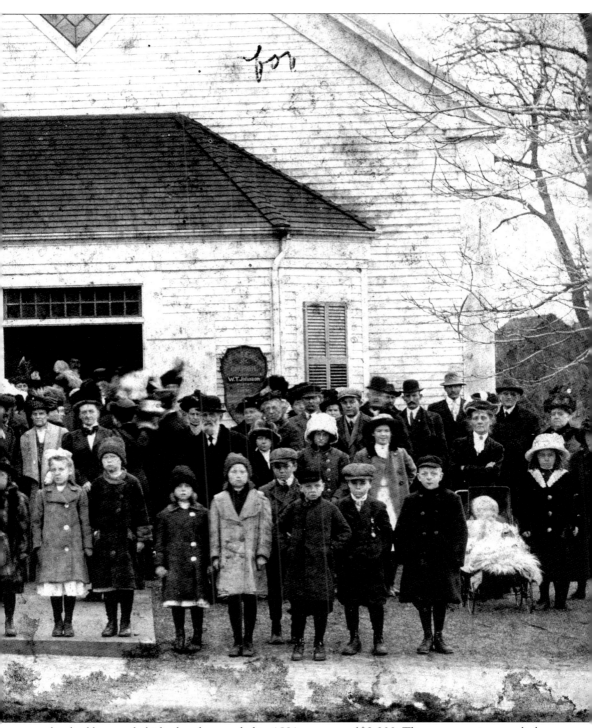

scales, had been refurbished and expanded in 1891 at a cost of $2,000. The congregation regularly sponsored revivals, evangelical meetings, and Women's Christian Temperance Union gatherings.

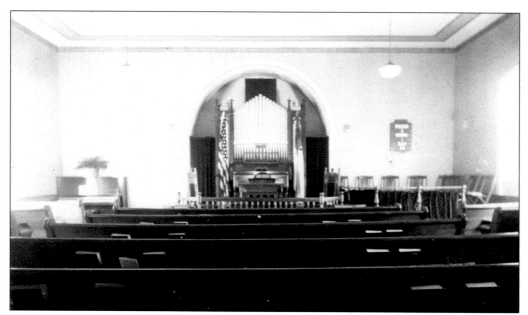

In 1910, the sanctuary of the Methodist Episcopal Church was furnished stylishly in the best of taste with carved oak pews, an antique oak pulpit, carpeting, chandeliers, a large clock, "singing seats", a pipe organ, and even a furnace. Extensive renovations had taken place in 1891, and the church then rededicated itself to its mission.

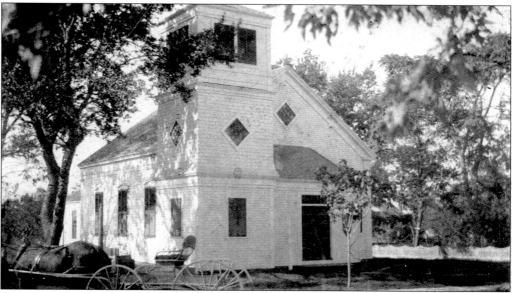

At the same time, the exterior of the Methodist Episcopal Church also had received an expansion and an update. The bell tower was added and the clapper of the bell put back into place. It had disappeared mysteriously months before, but was found hanging from a tree in front of the church just as the renovation approached completion. The church's congregation had come together in 1829, under the leadership of Oliver Hinckley, and the original church building was completed in 1847. Most of the original membership were Hinckleys, Cammetts, Crockers, Blossoms, Phinneys, Lumberts, Parkers, Scudders, or Lovells.

Sunday schoolers from the Baptist Church gather under the trees at their 1902 spring picnic. Pictured here from left to right are (first row) Hazel Ames, Cecil Goodspeed, Sarah Alley, and Burton Chadwick; (second row) Guy Jones, Maurice Allen, Hilton York, ? White, Dorothy Ames, Karl Chadwick, Bertha West, May Adams, and Norman Williams; (third row) Alice Jey, Harriet White, Beatrice Hinckley, Sybil Allen, Edith Alley, Herbert Hinckley, and Christie Ames; (fourth row) Olive Adams, Christine West, Isabel Williams, Mabel White, Owen Coleman, and Frank Allen.

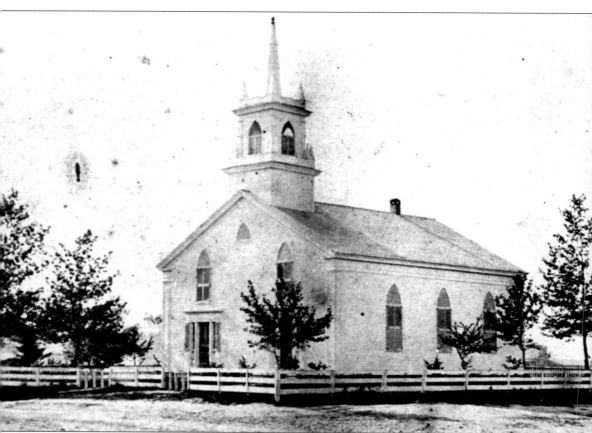

Construction of Osterville's Baptist Church was completed in 1837, and the exterior of the building looks much the same today as it did then. But in 1889, the interior was refurbished to reflect the prosperity of its congregation. The sanctuary was outfitted with three crimson plush speakers' chairs plus matching plush cushions for the worshipers. Some church leaders worried that the congregation might become so comfortable in this setting that it would "induce a sense of repose and so impair the effect of the eloquence that was sure to flow amid such surroundings." The church was founded in 1835 by families from the Hyannis Baptist congregation, mostly Halletts, Lovells, Smalls, Childs, Hinckleys, Cammetts, Blounts, Kelleys, and Joneses.

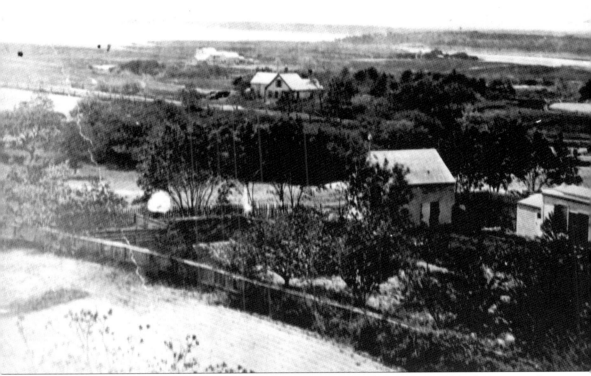

Anyone who climbed to the belfry of the Baptist Church in the 1860s could look out over the neighborhood where the families of Horace S. Crosby, Asa Crosby, and Oliver Coffin made their home. Grand Island (Oyster Harbors) is in the distance. Legend has it that a woman named Hannah Screecham lived alone on this island in the 1700s when pirates used it as a place to stash their loot. Some believe she and Captain Kidd were linked romantically, but others say the notorious pirate murdered her and buried her nearby. Even to this day, when the wind howls across the island's Noisy Point, many old timers will tell you that they can hear Hannah screaming for revenge.

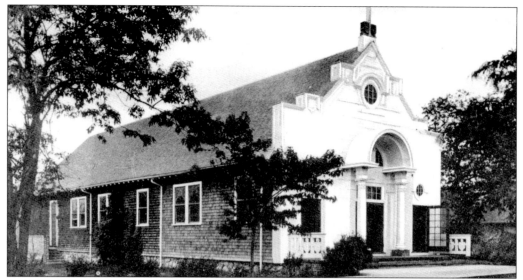

In 1882, Osterville's Catholic church began as a mission of St. Francis Xavier of Hyannis, and masses were held in Union Hall. The Charles Daniel family, who came to the village in 1879 to work for the William Lloyd Garrisons, is thought to have been the first Roman Catholic family to settle here. Catherine Morris Daniel held catechism classes in her home for her children as well as young members of the Beaumont, Baker, and Hansberry families. The diocese purchased the land on Wianno Avenue in 1903, and in 1905, the new Church of Our Lady of Assumption opened its doors to the faithful.

In 1903, the Episcopal Diocese of Massachusetts decided to establish a summer chapel in Osterville and to name it after St. Peter. Designed to seat 115 communicants, the church cost $3,000 to build and furnish. It quickly became a very popular location for weddings and funerals. In 1975, the diocese expanded its mission, enlarged the facilities, and declared St. Peter's Church to be a year-round parish.

Six

SAILING FOR PROFIT AND FOR FUN

By 1908, when this postcard was in the stores, sailboats of all shapes and sizes had become Osterville's trademark, although none are known to have been found inside a seashell. For two centuries, the water provided the people of Osterville with most of their livelihood. Boys regularly went to sea at eight or nine as cooks or cabin boys, and sea captains were the heads of the village's most prosperous households. With the decline of the whaling industry and the advent of the steamship, Osterville families turned to other ways of making a living. But sailing was in their blood, and what they had done for profit, they now did for fun.

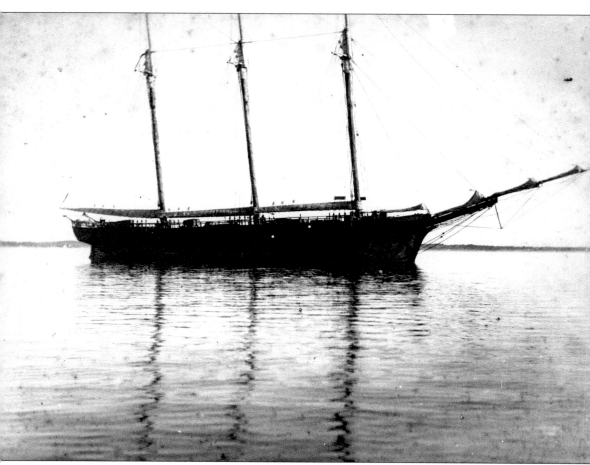

One of the most majestic schooners to be moored in East Bay around 1886 was the *William L. Burroughs*, captained by Nathan E. West Sr. The vessel was only the second three-masted schooner built in the United States. It was designed by Eckford Webb, a boatbuilder famous for his pilot boat models. Those in the know ranked this ship as one of the fastest in the coasting trade.

On January 9, 1886, the schooner *Congress* from Bath, Maine, slipped its anchor in Hyannis harbor and ran aground in front of the Cotocheset House piazza. Neighbors, hotel guests, and staff rushed to pull the crew and passengers to shore, but the gale and rough sea prevented rescue until hours later.

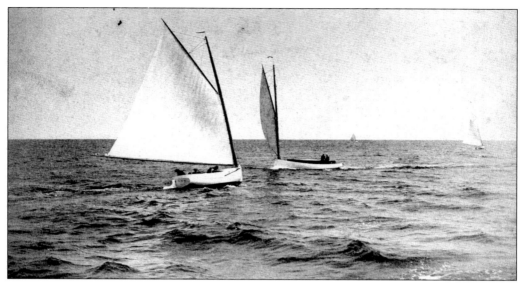

On a calm and sunny day in the summer of 1886, two crews of young men race their "cats" across Nantucket Sound. Before the Crosbys built Wianno Juniors and Seniors, they already were master builders of these swift and agile catboats. Below, brothers Lou and Fran Loutrel skipper the *Pequod*, their Wianno Senior Number 43, in a Wianno-to-Hyannisport race around 1935.

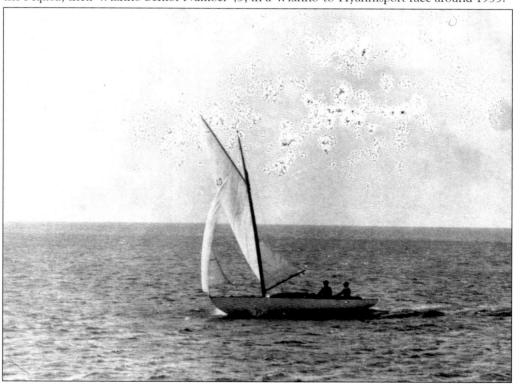

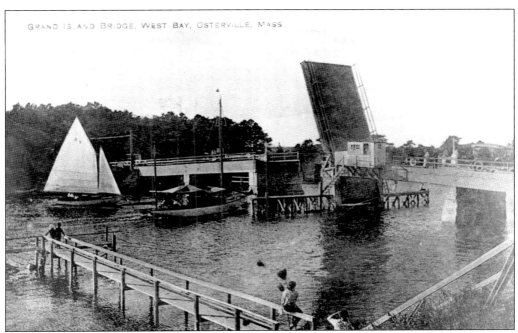

Boats large and small wait their turn around 1920 to go through the Grand Island drawbridge that connected Oyster Harbors with greater Osterville. This cement structure was built in 1911 to replace a more primitive and less sturdy double-draw bridge made of wood. The bridge in place today was built in 1946. Below is a view of the bridge as a sailor would see it from West Bay.

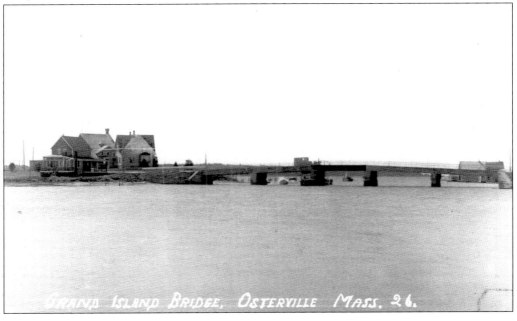

GRAND ISLAND BRIDGE, OSTERVILLE MASS. 26.

Brisk winds off Nantucket Sound catch and stretch the American flag in front of the original Wianno Yacht Club, known for years as Mrs. Hill's Cottage. In the 1880s, it stood immediately to the left of the town landing at the head of Wianno Avenue. In the late 1800s, the yacht club was a favorite meeting place for Osterville's summer people. Every season, the club sponsored a series of catboat races for members and non-members as well as events for "modern and more expensive craft." For many years, the yacht club was affiliated with the larger and more elegant Wianno Club, but now it is an independent organization. Below, a Cape Cod "black dog" waits patiently on the beach for his master to return from an afternoon sail on East Bay.

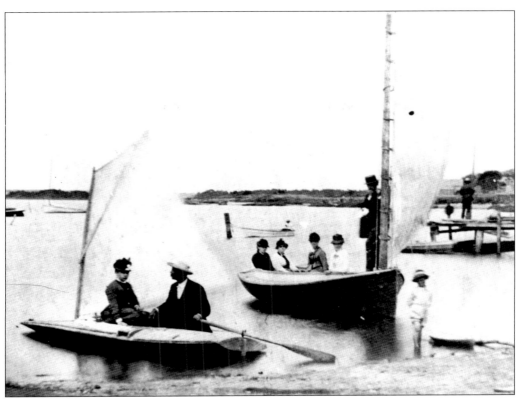

In 1885, Osterville ladies wore petticoats and pantaloons even when they boarded small boats for a cruise across the bay. Here, a group of "sailors" cast off from the beach in front of C. Worthington Crosby's boat shop. Below, by 1920, the Crosby Wianno Seniors were the racing boats of choice. Here, the local sailors jockey for position in North Bay before the starting gun goes off.

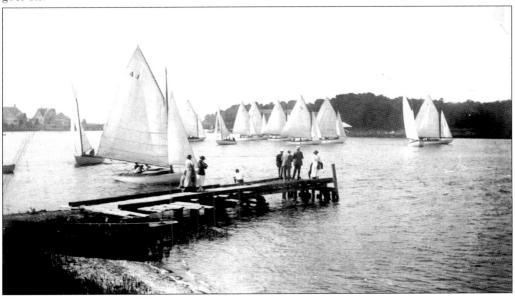

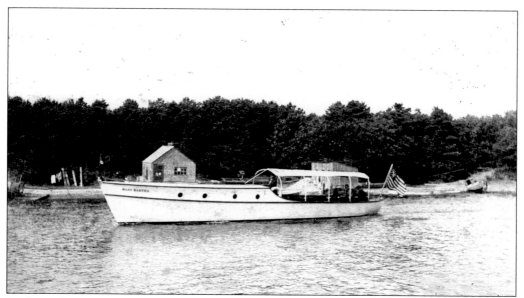

In the early 1900s, private yachts driven by engines rather than air began to visit Osterville waters. Around 1910, Charles Dwight Armstrong purchased a launch and named it for his daughter, Mary Martha. He hired Fred Parker to be the captain. The Armstrong Osterville estate was known as Indian Knoll, and its owner was president of the Armstrong Cork Company of Pittsburgh. In 1930, the Armstrong family gave eight acres of the property to the village to establish the Armstrong-Kelley Horticulture Park.

In 1884, Orville D. Lovell installed a state-of-the-art boathouse on East Bay below The Bluffs on Main Street, where he was later to build an elegant "cottage." George F. Lovell, Orville's nephew, relaxes on the balcony. Capt. Owen Crosby is in the doorway, and Howard Marstons sits on the wharf next to Orville's sailboat, *Dipper*. Marstons and Orville were devoted yachting and hunting partners until they parted ways as the result of a legal dispute.

Seven

NEIGHBORS
AND NEIGHBORHOODS

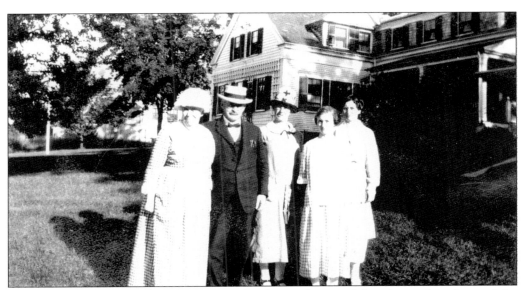

Village physician Dr. William D. Kinney, family members, and friends stand in front of the Kinney home at the intersection of Main Street and West Bay Road. The doctor was born in New Brunswick, Canada, in 1873, and he grew up there. After graduating from Bowdoin College in Maine, he came to Osterville in 1900 to launch his medical practice, and he stayed. Kinney ministered to villagers' aches and emergencies for more than 46 years.

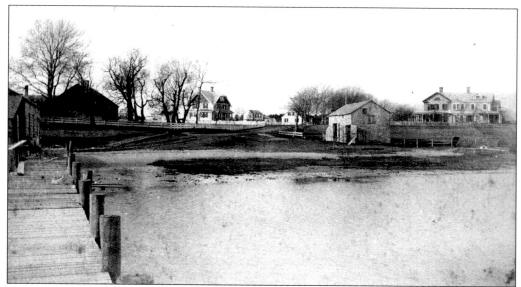

The pier off East Bay Road offered strollers around 1890 a panoramic view of some of Osterville's most elegant seaside homes. From left are houses belonging to Seth Goodspeed, Nelson H. Bearse, Josiah Ames, and schooner captain Henry Linnell. A solitary cow completes the landscape.

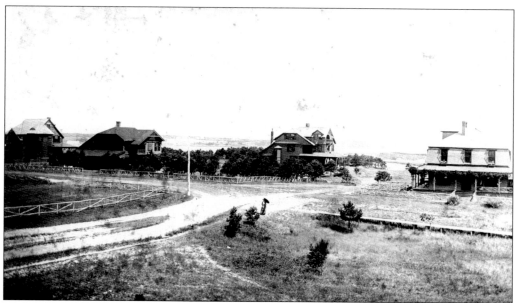

In the 1890s, some of Osterville's most gracious waterfront homes stood near the intersection of Wianno Avenue and Phelps Corner. The crossroads was named for businessman George H. Phelps, manager of George Frost and Company of Boston, a clothing manufacturer. He and his family summered in Wianno, and he served on the board of the Osterville Improvement Association.

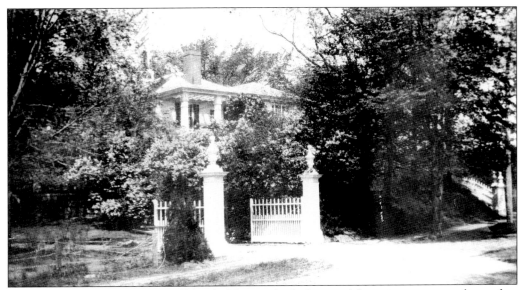

This sedate and stately house, all but hidden in the lushness of flowering trees, was located at the corner of East Bay Road and Main Street. It was built by schooner captain Shubael Baxter in 1829. In 1854, at the age of 73, he married his second wife, a Mrs. Goss, who was then 35, and they lived in this lovely home. When Dr. Thomas R. Clement bought the house in 1882, he named it Twombly's Corner after his daughter Mrs. J. S. Twombly of Brookline. The physician had served as a doctor in the Union Army during the Civil War, and after moving here, he practiced medicine in Osterville until his death in 1898.

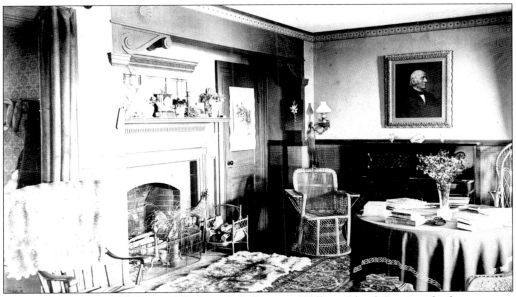

Boston newspaper publisher and firebrand abolitionist William Lloyd Garrison built a summer cottage not far from the Cotocheset House in Wianno. Although he was in Osterville only part time, he took great interest in its welfare. In 1880, he single-handedly raised enough money to build the village's first library. Here, his portrait hangs above the piano on the right-hand wall of his parlor, which was photographed in 1883.

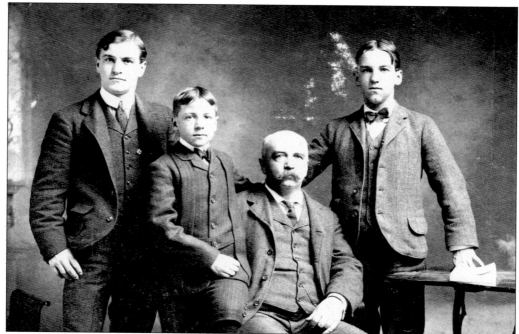

Osterville native J. Porter Scudder and his three sons, Ross, Oliver, and Harold, sit for a family portrait around 1890. For nearly 60 years, Porter owned and operated the Scudderr-Kee Company, a women's apparel store in Brockton. The Scudders visited their relatives in the village several times a year, and in 1918, they contributed the funds to install electric lights in the Methodist Episcopal Church in memory of Porter's parents, Josiah Scudder and Augusta Hinckley Scudder.

Everett Churchill Alley (always known as Churchill) built this comfortable home on Main Street in 1895. Here, he and his wife, Lena Ryder Alley, raised two daughters, Edith and Sarah. For most of his adult life, Churchill made his living as a painter at the Crosby boatyards.

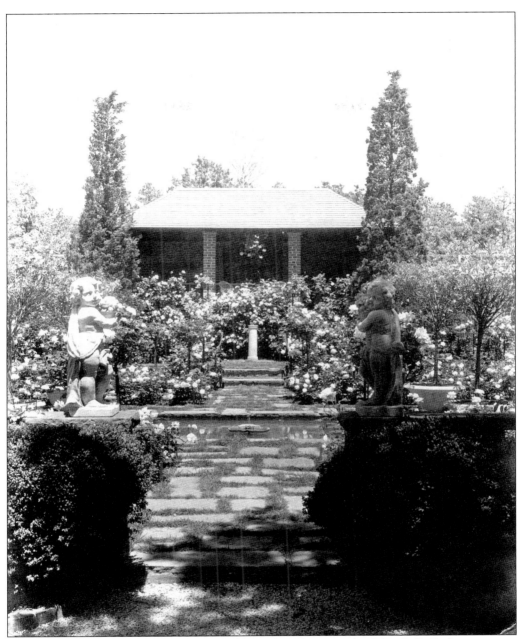

This dignified teahouse facing East Bay Road stood on the grounds of the C. D. Parker estate on Main Street. The entire estate was designed by Richard Elwes Pope. The rose garden surrounding the teahouse featured imported Italian statuary and a miniature castle. The grounds also contained a rock garden, a vegetable plot, and a swimming pool, all under the care and supervision of master gardener John B. Souza. Parker, a Boston businessman, was a relative newcomer to Osterville in the early 1900s and was not related to the village's founding Parkers.

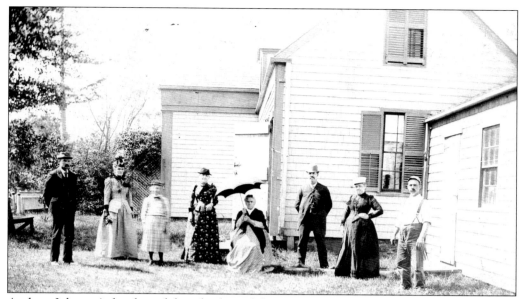

Andrew Johnson's family and friends, dressed for an outing, gathered in the yard of his Main Street home. From left to right are Charles Crosby, Carrie Rich Williams, Edna Crosby, Annie West Hodges, Medora Robbins Lovell , Wallace Lovell, Edith Robbins Crosby, and Abbott Robbins. Andrew Johnson, a prominent Providence businessman, was also a yachtsman and frequent patron of the Crosby boatyards. The house had belonged to John Blossom before Andrew and his wife, Atteresta Robbins Johnson, bought it for a summer retreat.

Ferdinand Crocker, born in 1812, went to sea at 14 and rose to the rank of captain in the European and Chinese trade. In 1845, he settled in New York City, where he founded the firm of Crosby, Crocker & Company Ship Chandlers and Grocers. He and his wife, Mary Lovell Crocker, came back to Osterville almost every year and stayed at the Cotocheset House.

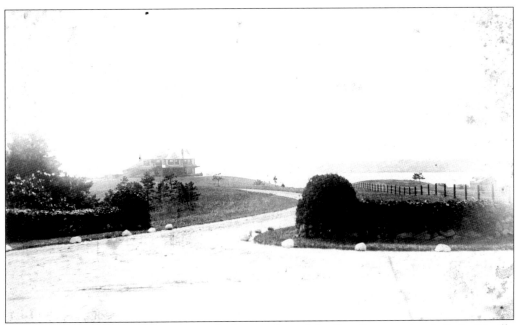

Even a Cape Cod fog could not diminish the grandeur of the East Bay mansion built by Orville Lovell and his wife, Augusta Bearse, in 1890. The large multi-level house stood on a bluff at the end of a long, winding driveway that led to Main Street. The couple named their new estate Yvery after the Lovell ancestral home in Great Britain. The estate was sold in 1907 to the William Lindsey family, who had summered in Wianno for several seasons.

Eliza Codd Corcoran and her sister, Adeline Codd Coffin, stand in front of their family's Bay Street home around 1896. Adeline is holding her son, Donald. Their father, James H. Codd, was born on Nantucket and moved to Osterville as a boy. A jack-of-all-trades, he occasionally went to sea as a crewman on the schooner *Pennsylvania*, which was engaged in the coasting trade.

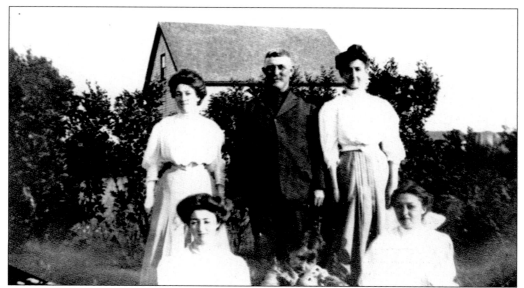

The Everett Childs family pauses for a picture in front of their home. From left to right are (seated in first row) children Angie, Verner, and Marion Childs; (standing in second row) daughter Evelyn Childs, Everett, and Nancy Coffin Childs, his wife. In 1905, Everett, who owned a stage route, obtained the contract to deliver the mail from West Barnstable to Osterville. In 1910, one of his best horses was hit by an automobile and had to be shot. Before long, he upgraded his mode of transportation to motor-driven trucks and buses.

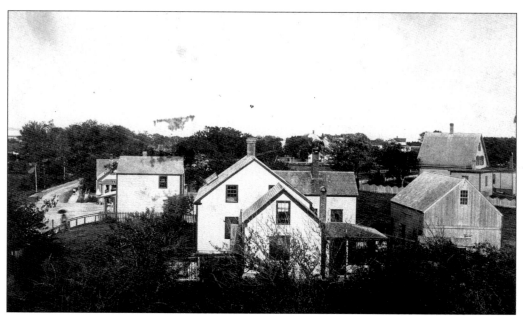

Around 1890, the intersection of Main Street and Wianno Avenue was home to the Joseph Robbins family. The Capt. Horace Lovell family lived next door. (After he retired, the former sea captain was head of the village school committee for many years.) Later, the Robert Daniel family lived in the house on the right. Daniel was a local building contractor. At the left is Crocker's Store.

Deep in the trees at the corner of East Bay Road and Main Street stood the home of Thankful Hamblin Ames, who for many years was the proprietor of the Cotocheset House. Considered an independent-thinking businesswoman, she had earned the distinction of being one of the first four ladies to vote in Osterville after the Women's Suffrage Constitutional amendment took effect in 1920. Her husband, Granville Ames, died in 1886, and Thankful made her own way until 1934, when she died at the age of 88.

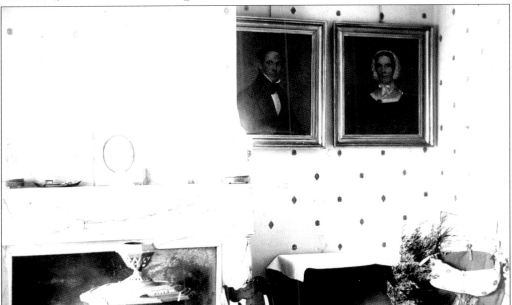

Portraits of the former master and mistress of the house dominated the parlor wall around 1890 in this East Bay Road home built by Capt. George Lovell and Adeline Hallett Lovell. During the War of 1812, the captain was captured at sea and was imprisoned by the British until the war ended. Once back on Cape Cod, he rejoined the coastal trade and stayed with it most of his life. At the time of his death in 1861, his estate included 17 schooners.

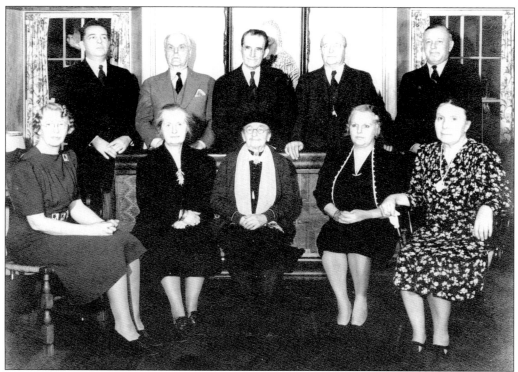

In 1939, the town of Barnstable (Osterville included) marked the 300th year of its founding. Descendants of many pioneer families had the honor of serving on the committee to plan the celebration. Among the members from left to right are (first row) Genieve Leonard, Evelyn Crosby, Ora Hinckley, Mrs. Paul Swift, and Elizabeth C. Jenkins; (second row) Don Trayser, Reginald Bowes, James McLaughlin, Alfred Crocker, and Thomas Otis.

Three elegant homes and the Cotocheset House shared this expansive view of Wianno Beach and Nantucket Sound as seen from Seaview Avenue around 1900. From left, after the inn, are the estates of the H. D. Tiffany family of New York, James Tolman of Boston, and W. H. Blodgett of Newton, Massachusetts.

Eight

SAILORS AND SOLDIERS

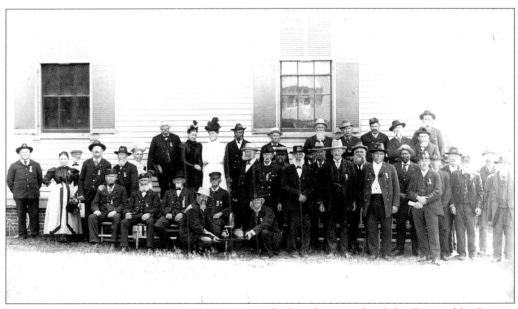

On July 13, 1899, S. A. Putnam of Hyannis took this photograph of the Barnstable County Association of the Grand Army of the Republic (GAR). All the men present fought for the North under Massachusetts banners between 1861 and 1865 in the Civil War, often called the War Between the States.

David Fuller Jr. (pictured with his wife, Eunice Cathcart Fuller) enlisted as a private in Company D, 45th regiment of the Massachusetts Volunteers and fought in the battles of Kingston and Whitehall and at Goldsboro, North Carolina, where he was wounded. When he died in 1916 at age 72, a delegation of his GAR comrades performed the Retreat of their Order at his grave. Often called "Commander", he served for several years as patriotic instructor for the village schools.

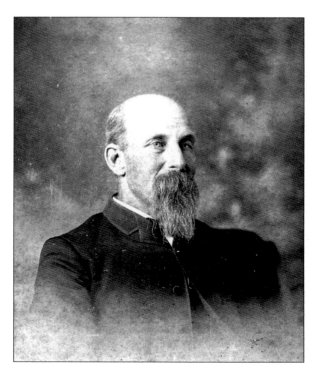

Watson F. Adams fought with the 24th Massachusetts Regiment during the Civil War. Although he came home unharmed, many Osterville soldiers were not so fortunate. Among those wounded or who became seriously ill were Henry Goodspeed, Howard Lovell, Josiah A. Ames, Osmond Ames, and James B. Jones.

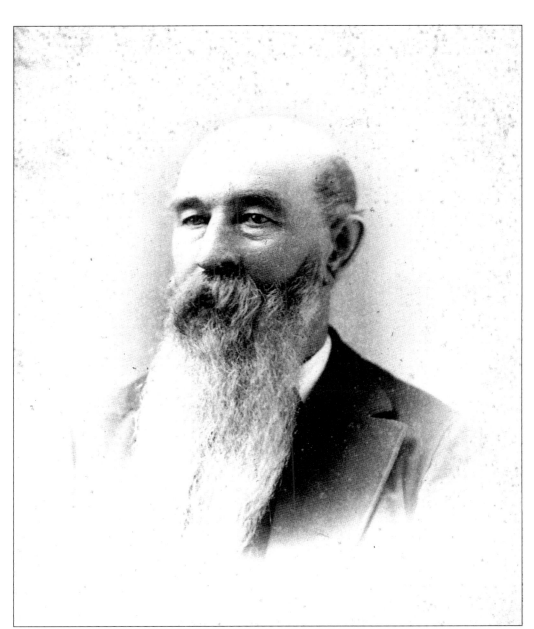

Twenty-year-old Josiah A. Ames went to sea during the Mexican War of 1847, serving on board the U.S. Sloop of War, *Jamestown*. He came home in 1849, determined to seek out more danger and adventure and headed for the California goldfields where he spent several years as a prospector. When Josiah returned to Osterville, he married Asenath Backus, daughter of John Backus and Christina Jones Backus, and they had three children. Still not content to settle down and grow old on Cape Cod, Josiah, at 35, enlisted as a private in the Union Army. He fought in Civil War battles in Virginia and South Carolina and was wounded several times. Years later, his son, Chester, chose to follow his father's military footsteps and joined the U.S. Navy.

Stephen West, who was born in 1784, fought against the English in the War of 1812. He married his wife, Thankful Hamblin West, just before he enlisted. They had 12 children; one of them grew up to become Osterville's legendary sea captain Nathan West Sr.

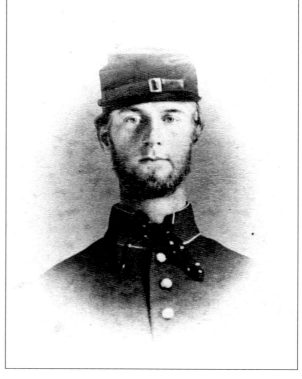

Pvt. Joseph C. Scudder made it home in 1864 although severely ill, but he died soon after he arrived in Osterville. He was 23 and had fought with Company E, 40th Massachusetts Regiment. Other village boys listed among the dead from wounds or disease were Obed Cahoon and Adelbert Kelley.

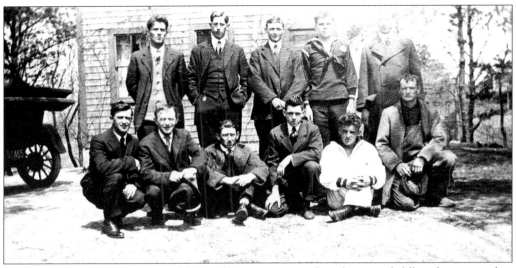

In the spring of 1917, a group of Osterville's young men, friends since childhood, got together one last time before most went off to war. Pictured here from left to right are (first row) Arthur Wyman, John Horne, Verner Childs, Leo Beaumont, Maurice Allen, and Eben Harding; (second row) Ernest Jones, Jesse Murray, Eddie Sullivan, Karl Chadwick, and Leon Hinckley.

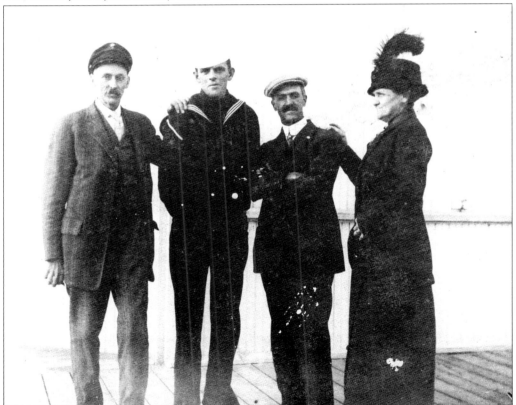

In 1917, Frank Williams (left), Elliott Crosby (center right), and his wife, Hattie, bid farewell to Karl Chadwick (center left) as he was about to leave for duty with the Naval Coast Defense Reserve.

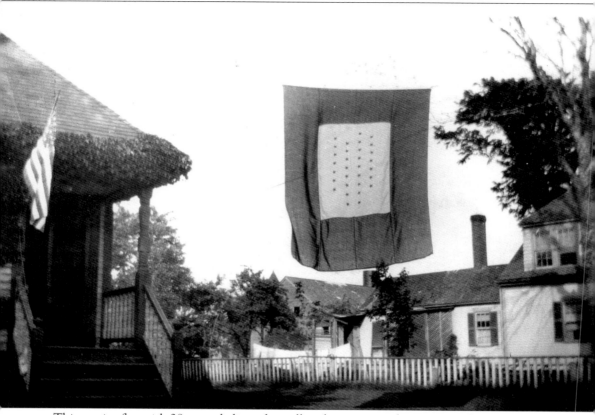

This service flag with 28 stars, dedicated to village boys serving their country during World War I, hung for many months between the Lagergren family home and the old Osterville Public Library on Main Street.

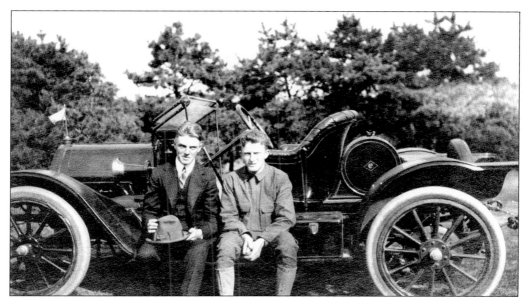

Pfc Shirley Evans (right) joined up in September 1917 and sailed for France in January with the 301st INF Repair Unit. Here, he is seated on the running board of a 1911 Reo with Ralph Williams as they speculate about their futures. Shirley served in Europe for 18 months.

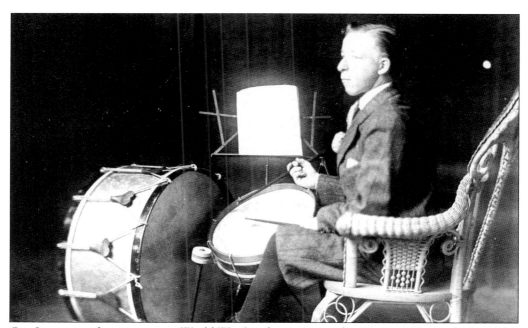

Guy Jones served as a private in World War I and was stationed at Veterans Hospital, No. 176th Division. Before he joined up, the son of Frank Jones and Eunice Smith Jones worked for a drum factory in Boston. At home, he played with the Osterville Band.

Pfc Malcolm Crosby (left) and Pfc Carroll Crosby, sons of boatbuilder H. Manley Crosby, fought with the World War I American Expeditionary Force in such major encounters as Chateau Thierry, Verdun, and the Battle of the Marne. At Chateau Thierry, Carroll was gassed and suffered from the effects of the exposure for the rest of his life.

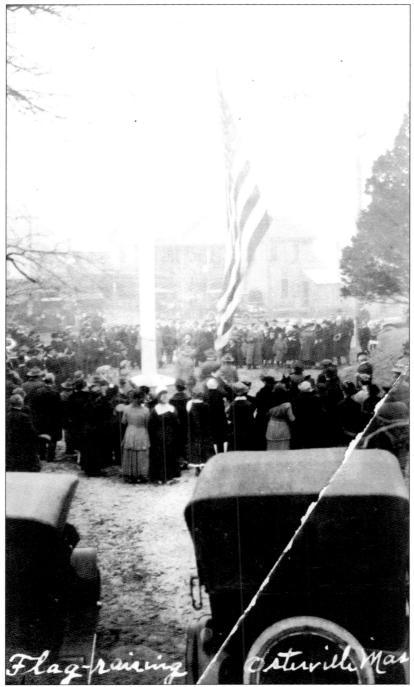

Flag-raising / *Osterville, Mass*

In November 1918, the people of Osterville decided to celebrate the end of the War to End All Wars by perpetually flying an American flag in the center of the village. Instead of purchasing a new pole for this patriotic dedication, they chose to salvage one of the masts from a schooner that had run aground a few months earlier off Wianno Beach. After the armistice was signed, a boulder bearing the names of all villagers who had served was placed nearby.

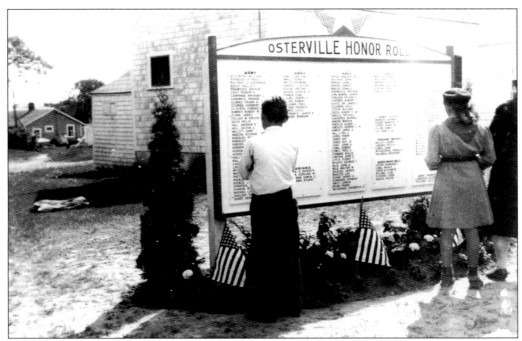

A villager and a local Girl Scout scan the Osterville Honor Roll listing all who served in World War II. The plaque first stood in Osterville Center and later was moved across the street to the community center. Almost the entire town turned out for the dedication of the memorial.

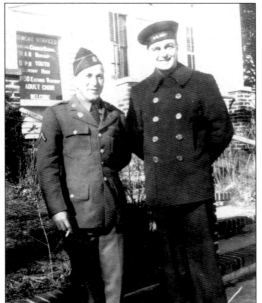

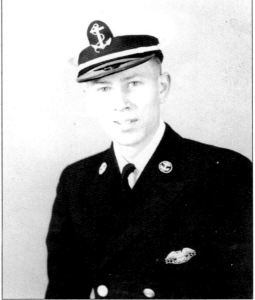

Soldier Henry Small (left) and sailor Elbert Little greet each other in front of the Baptist Church in July 1944 while both were home on leave. Philip Leonard (right), the son of Burleigh Leonard and Jessie Boult Leonard, served as an officer in the merchant marine, ferrying supplies from the United States to France and Belgium. An Osterville Band member before World War II, he played sousaphone.

Nine

SUMMER PEOPLE

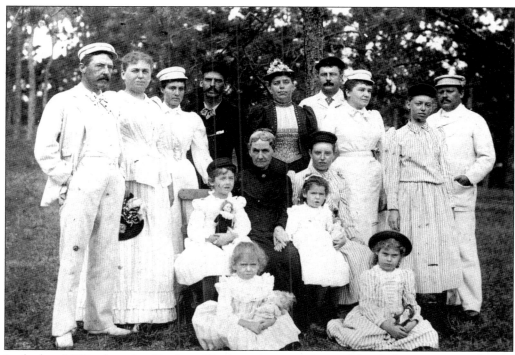

In the late 1880s, three families from Cincinnati got together and decided to create a residential compound in Osterville on the bluffs near the mouth of the Centerville River. They called it Hi Ga Ho, an acronym for their family names, Hinkle, Gaff, and Holmes. Here, a representative group poses for a photograph. From left to right are (first row) Elsie Holmes and young Zaidee Gaff; (second row) Rachel Holmes, Grandmother Rachel Gaff, Violet Shillito, and Polly Holmes; (third row) Daniel Holmes, Dickie Gaff Holmes, Zaidee Gaff, Thomas Gaff, Jane Shillito, Charles Hinkle, Mary Gaff Hinkle, Mary Shillito, and Gordon Shillito.

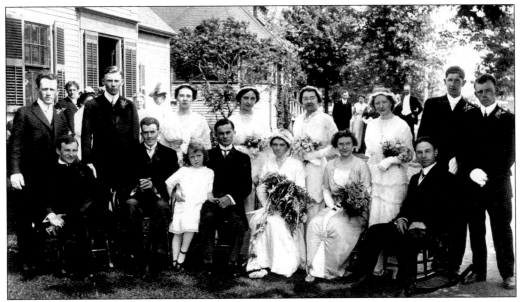

One of the loveliest weddings in Osterville in 1914 united Dexter Pattison and Addie Crocker. Members of the large wedding party from left to right included (front row) the Rev. Paul Smith, Joseph Tallman Jr., Marion Lovell, the bridegroom, the bride, Aleria Crocker, and the Rev. Plaxton; (second row) Mr. Davidson, Winthrop Scudder, Etta Erquhart, Josephine Wallon, Lucilla Thayer, Margerie Leonard, Jessie Murray, and Frederic Scudder. The ceremony took place in the Methodist Episcopal Church. The bridegroom had just graduated from Boston University Law School.

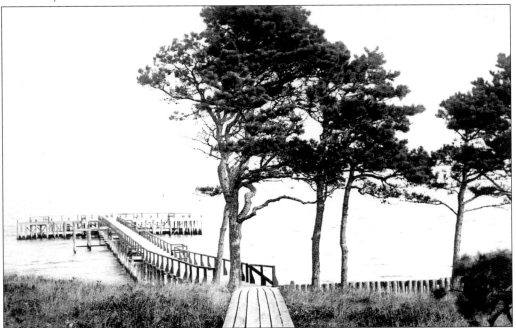

This simple but sturdy wooden pier, located at the foot of Wianno Avenue near the Cotocheset House, served village boaters from 1890 to 1910.

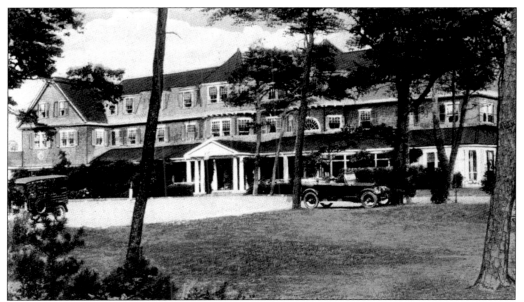

In 1873, a consortium of Scudders, Chadwicks, Chaplins, and Crockers announced plans to build a grand hotel on the Wianno shore that would be surrounded by large "cottages," a location that the best families of Boston would be most happy to call their summer retreat. They decided to name it Cotocheset House, incorporating the Cotochese word for the area now called Wianno. In 1887, the hotel was destroyed by fire, but by July 1888, it had been completely rebuilt and was ready once more to welcome the elite of the elite. In 1916, the Cotocheset Company sold the property. It became a private retreat and was renamed the Wianno Club.

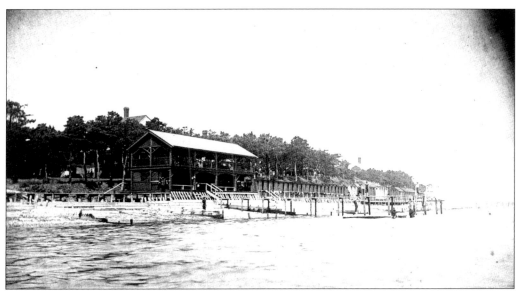

The bathing pavilion (around 1890) in front of the Cotocheset House on Nantucket Sound awaits summer swimmers and sunbathers.

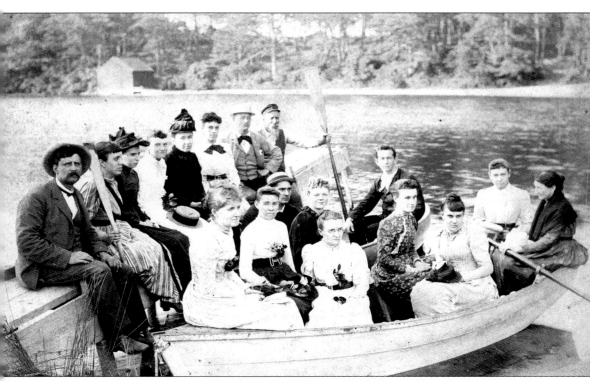

Cotocheset House proprietor Thankful Hamblin Ames (fifth from left), wife of Granville Ames, treats her staff to a Sunday outing on Crystal Lake. Among those in the group are Watson Adams, Lizzie Sturgis, Bessie Cammett, Flossie Jones, and Hattie Lovell. Ames ran the inn from 1878 to well past the mid-1890s. The original Cotocheset House burned down on July 19, 1887. Eighty percent of its household and personal articles survived, thanks to the quick action of Ames, her staff, and neighbors, but still the loss was estimated to be as high as $25,000.

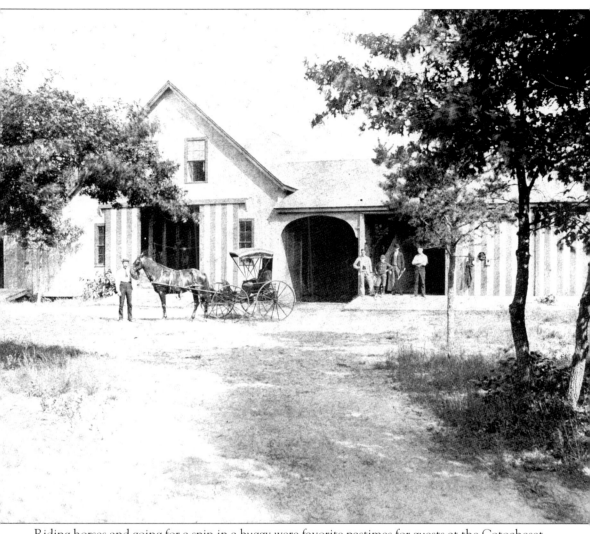

Riding horses and going for a spin in a buggy were favorite pastimes for guests at the Cotocheset House. The stables also provided a place for the manager, Capt. Daniel Bursley, to shelter his three stagecoach horses so they could rest and feed between trips to the West Barnstable train station to pick up new guests. The captain holds the distinction of installing one of the first telephone lines in Osterville, which connected his train station stable in West Barnstable with his Osterville home.

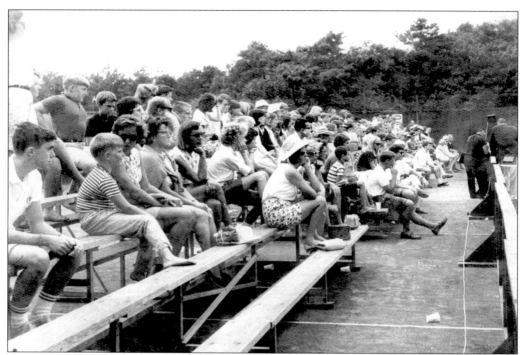

Tennis for all ages became a favorite pastime for members of the Wianno Club. Here a large group of spectators watch a match in progress.

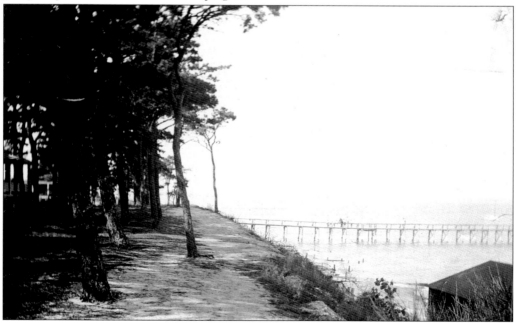

A path, around 1900, winds across the top of the bank above Wianno Beach looking much as it did in Colonial days. In 1920, a Cotochese burial ground was discovered nearby on the William Lloyd Garrison property. Perhaps in an earlier time the Native Americans walked along here on their way to fish in Nantucket Sound.

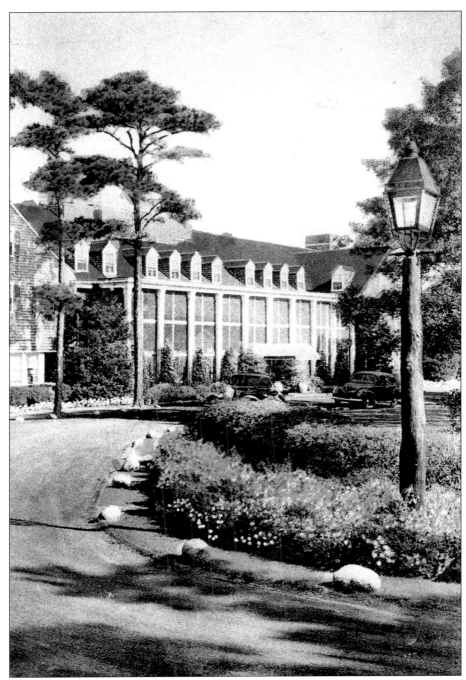

The Oyster Harbors Club, around 1930, was the centerpiece of an exclusive residential area located on two small islands just off the Osterville mainland. Developer Forris Norris of Boston bought the property in 1925. Within three years, he transformed it into a first-class private summer resort complete with a four-story clubhouse, a golf course, safe boat harbors, and equestrian facilities. In 1968, the original clubhouse burned down but was replaced by an equally magnificent structure.

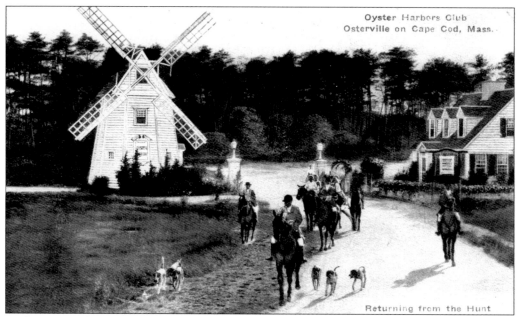

Foxhunters and their dogs meander along the road past the guardhouse at the entrance to Oyster Harbors. In 1976, the guards began to keep a log, which records the fact that in one summer 1,000 cars were turned back from the gate. The windmill, built in 1926, was originally the architect's office. No longer used, it appears in the club's logo.

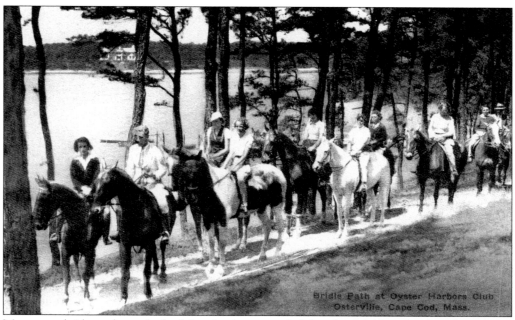

More casual riders take to the bridal paths that encircled the island. Miles of such paths radiated out of the stable for the enjoyment of members and guests.

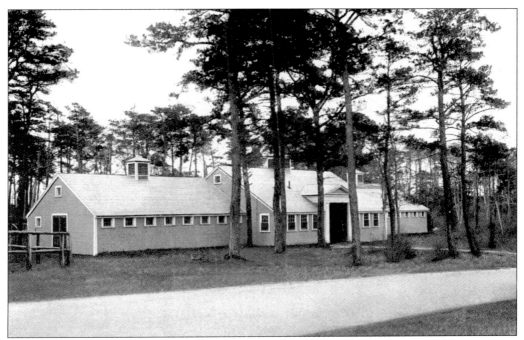

The Oyster Harbors riding center on Little Island housed a stable full of splendid horses. From 1929 to the early 1940s, the Oyster Harbors Horse Show was a major event of the Labor Day weekend. A Twilight Hunt was added to the equestrian calendar in 1933, and the club borrowed a pack of English hounds from a hunt club in Cleveland to take part in the event.

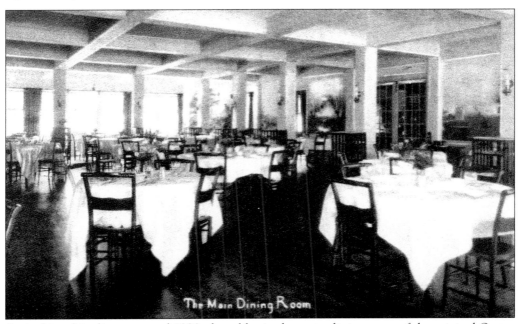

Attired in white linen, around 1930, the tables in the main dining room of the original Oyster Harbors Club await the evening guests. Colonial in decor, the room overlooked the golf course and Nantucket Sound.

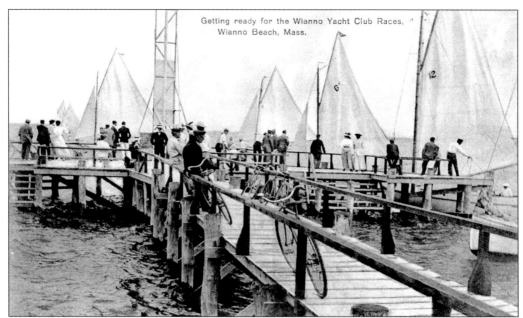

Sailors gather at Wianno Beach in anticipation of the start of a Wianno Yacht club race. Many of the postcard pictures, such as this taken in the early 1900s, were the work of Louis Huntress, who had a studio at the corner of Parker Road and Bay Street that was open only in the summer. The rest of the year he and his camera traveled from Massachusetts to Florida taking photographs for other clients.

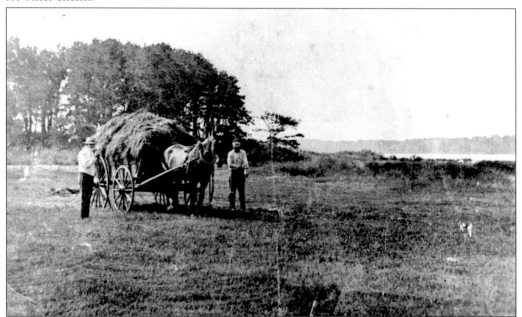

Before Oyster Harbors became a playground for the well-to-do, the island was covered each year with an abundant crop of marsh grass providing Osterville's mainland farmers with the perfect spot to harvest hay for their livestock. Here, Simeon Leonard (left) and a hired hand load up their wagon on Little Island.

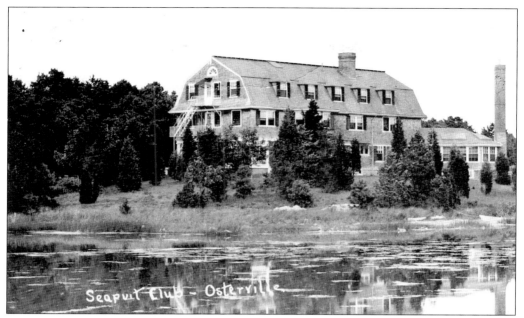

The stately Seapuit Clubhouse was built in 1898 to enhance the amenities at Seapuit Golf Links on North Bay, where Osterville's visitors and residents came together each weekend to enjoy the challenge. The clubhouse, which offered guests a choice of nearly 50 rooms for overnight stays, was demolished in 1932.

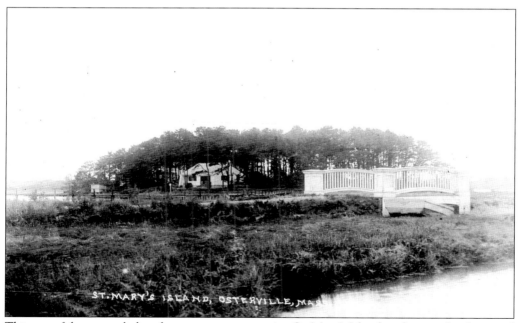

This graceful gateway led to the causeway connecting St. Mary's Island to the mainland, around 1910. A lone house rises in the background. The island is just across an inlet off North Bay from where the Seapuit Clubhouse stood.

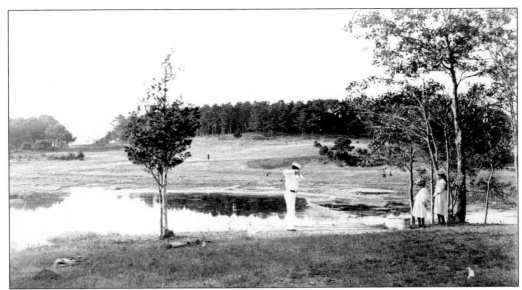

A serious golfer, around 1890, concentrates on clearing a small inlet at the Seapuit Golf Links, while two young girls watch from the sidelines. In the 1920s, regular players included Ralph Williams, Maurice Allen, Henry Whiteley, and Karl Chadwick. Below, first-time golfers walking over the crest of the hill at Seapuit Golf Links were greeted by a spectacular view of North Bay. The photographer of the day was summer resident George H. Phelps.

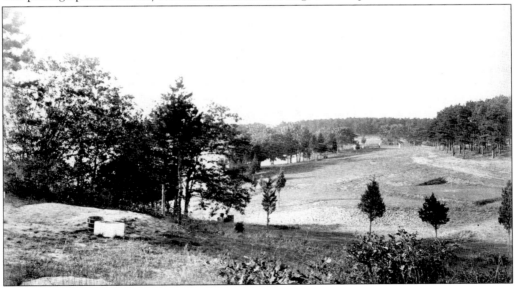

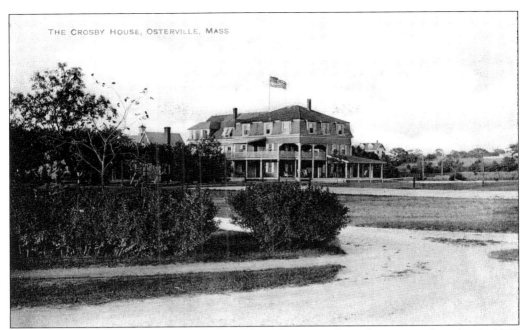

The original Crosby House on West Bay Road was first opened to a few summer boarders in 1860 by Horace and Lucy Crosby. Each year, as demand increased, the owners added on to its capacity until, by 1927, it could accommodate 50 guests. After Horace died, his wife, Lucy, was in charge, and later their grandson Harold Crosby took over the business. In 1927, the inn was sold.

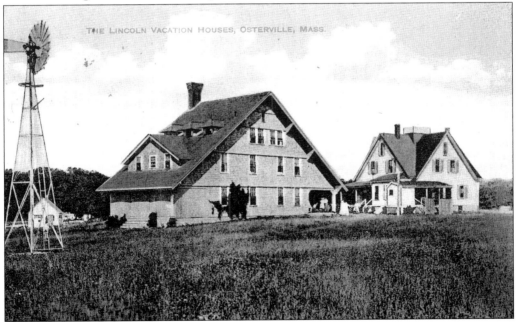

In 1895, the Josiah A. Ames house at Breezy Bluffs (right) became a summer get-away spot for needy boys and girls from Boston. Called the Lincoln House in recognition of its sponsor, Boston's Lincoln Club, the building soon overflowed with young guests. In 1899, a second building was added to the complex, which was located near the bridge to Oyster Harbors.

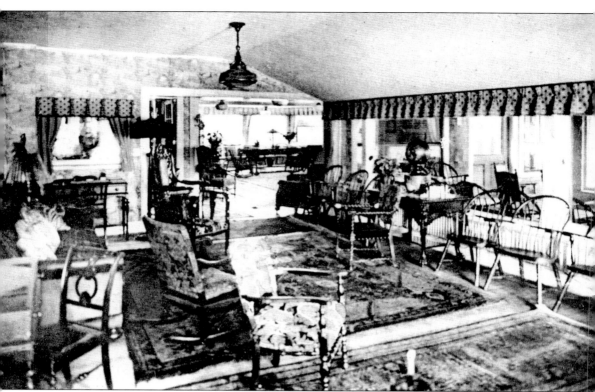

Oriental rugs on the floor of the sitting room in East Bay Lodge created a more elegant atmosphere for its guests than the usual beach resort of the early 1900s.

Ten

VIEWS AND VISTAS

Dowse's Beach, with East Bay in the distance, was known in 1883 as Wianno Beach or Dry Island. In 1895, William Bradford Homer Dowse, a lawyer and businessman from Cincinnati, purchased the property and built a large cottage there. In 1920, he represented Pres. Calvin Coolidge at the tercentenary celebration in Holland, marking the 300th anniversary of the landing of the Mayflower at Plymouth. Over the years, he served as president and director of the Wianno Club. In 1944, his great house was destroyed by a hurricane. The family gave the area to the village of Osterville, and it became known as Dowse's Beach. William Dowse and his wife, Fanny Lee, were one of the founding families of the Wianno summer colony.

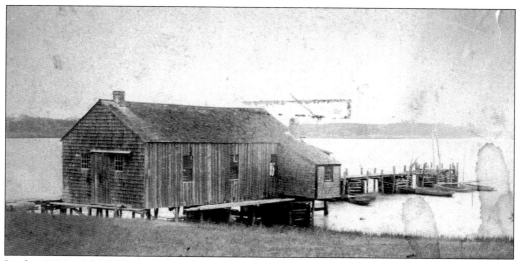

In the 1880s, Jehiel Hodges's boathouse dominated this corner of East Bay. A sea captain for many years, he skippered the schooner *R. H. Huntley* in the coastal trade. In 1882, the captain, then 55, and his wife, Elizabeth Scudder Hodges, moved to Florida where their sons, Freeman and Henry, had a very successful lumber business

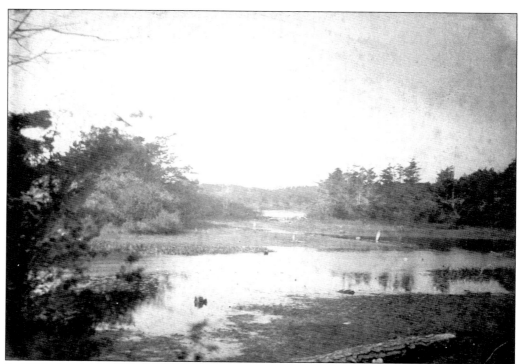

In 1884, the photographer stood on a small dam to take a picture of the millpond at the Heman Hinckley farm on the banks of Bumps River. The mill was a favorite gathering place for neighbors who exchanged bits of gossip and farming advice while they waited for their corn to be ground into meal.

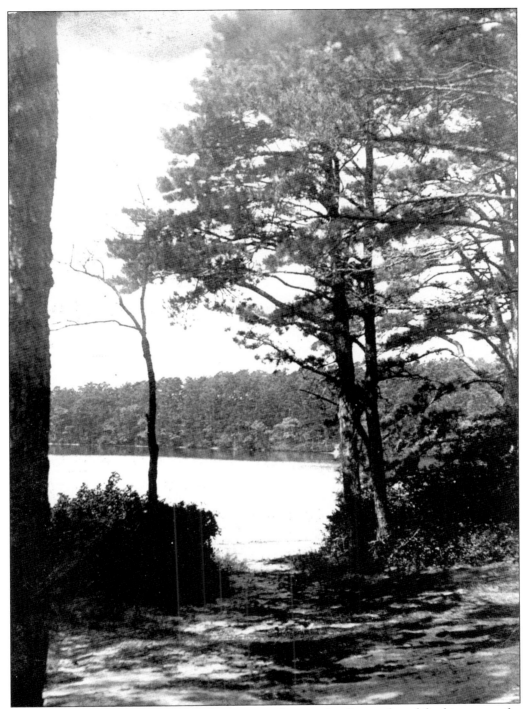

Neck Pond in the mid-1800s was a favorite spot for watering livestock and fetching water for cooking and cleaning. The pond appears serene today, but in the 1840s, it was the subject of a heated land tug-of-war between the Lovells and the Halletts. Today, it is part of the Wianno Golf Course.

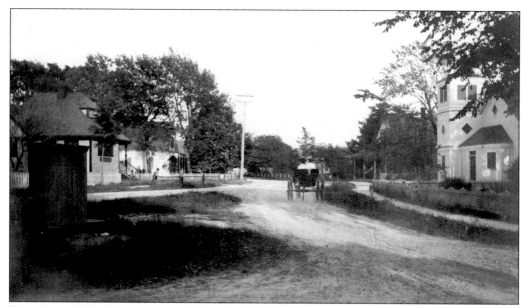

Two Osterville ladies, out for an afternoon buggy ride, pass through Osterville Center around 1900. On the left are the village hay scales. On the right is the Methodist Episcopal Church, perhaps their destination. There they might attend a meeting of the Women's Christian Temperance Union. Note the telephone pole in the center of the photograph. By the early 1900s, Osterville was wired to the outside world.

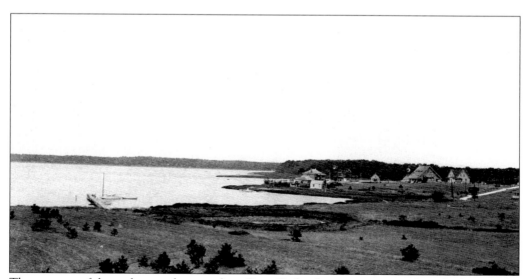

The expanse of sky and water that envelops Cape Cod today was even more breathtaking in the early 1900s. Here, the vastness of the view transforms the houses on Bridge Street into a village of miniatures.

A spot to stand on the edge of Bumps River in Centerville, around 1890, provided the viewer with a spectacular panorama of the Osterville marshes as well as an admonition. The sign reads: "Crossing the Bridge: Keep to the right and save wear."

Guests coming to the Cotocheset House around 1890 caught their first glimpse of the stately inn through a forest of pine trees lining both sides of Seaview Avenue. Chances are they had come to West Barnstable on the train and had traveled to Osterville in Capt. Daniel Bursley's stagecoach.

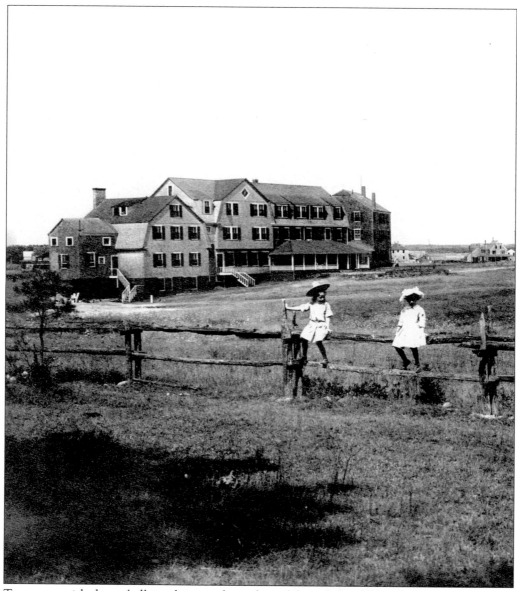

Two young girls dressed all in white perch on the rail fence behind West Bay Inn on Eel River Road around 1910. The summer hotel, which burned down in 1935, offered a choice of 65 guest rooms. Edward S. Crocker was the owner and proprietor.

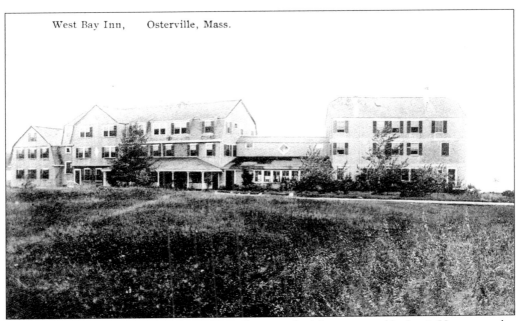

West Bay Inn, Osterville, Mass.

The West Bay Inn in its hey day (1920) was photographed for a postcard by Louis Huntress, who billed himself as "the photographer of Osterville." Below, this cozy sitting room, furnished with caned rocking chairs, offered guests a panoramic view of Nantucket Sound as they listened to music provided by a player piano.

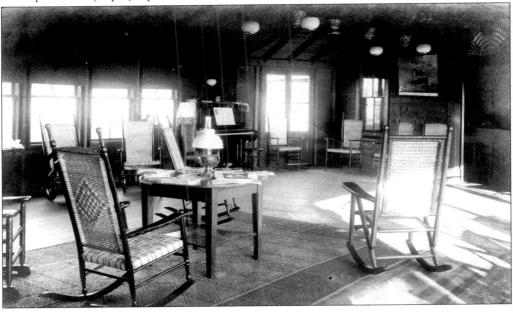

Sailors relaxing on the lawn chairs outside the Wianno Yacht Club in the early 1940s looked out on this tranquil scene across West Bay. The small sailboats are Wianno Juniors, a favorite of the local racing crowd. Below, while the sailors are taking it easy, shoppers and their cars crowd Main Street in the center of Osterville on a summer Saturday afternoon. On the right are the Baptist Church and the Gulf service station.

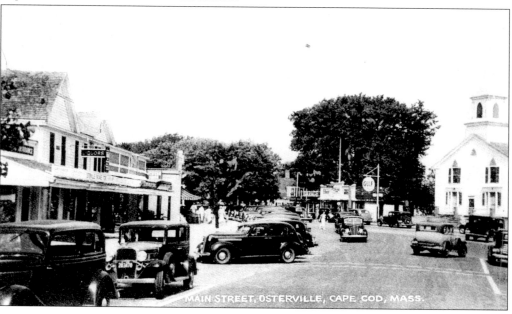

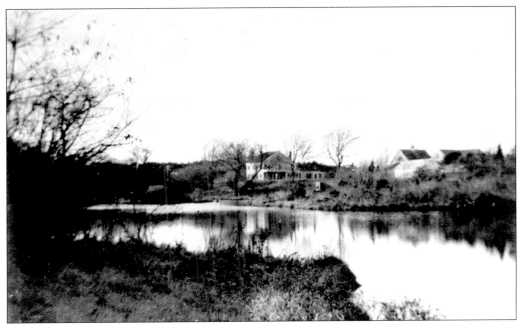

Osterville was, and is, a village of kettle ponds carved out by the glaciers that came with the Ice Age thousands of years ago. In 1887, George Lovell and Adeline Hallett Lovell chose Fraser's Pond, near the intersection of Bates Street and East Bay Road, for the location of their home.

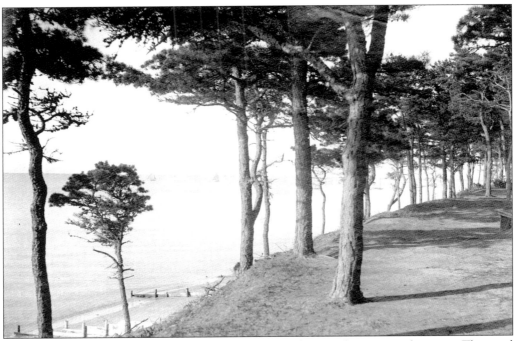

In the early 1900s, Wianno Beach, on a bright summer day, was the picture of serenity. The word Wianno is an alternate spelling of Iyannough, the name of the sachem or chief of the Cotochese Native Americans who called this area home in the mid-1600s.

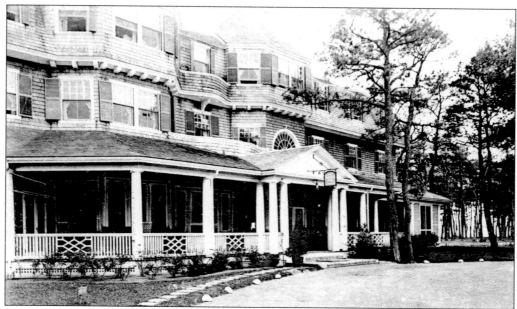

The Wianno Club on Seaview Avenue, formerly the Cotocheset House, still looks much the same today as it did in 1916 when the dignified old inn was sold by the Cotocheset Company and turned into a private family clubhouse. The new owners also purchased land nearby for an 18-hole golf course. Below, the Wianno Club's brick terrace overlooking Nantucket Sound was furnished in the year of the sale with comfortable caned rockers and chairs. The sender of this postcard writes that a formal bed of dwarf evergreens lined the veranda at the front entrance to the stately building.

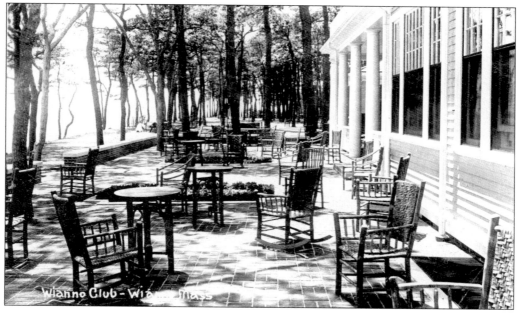

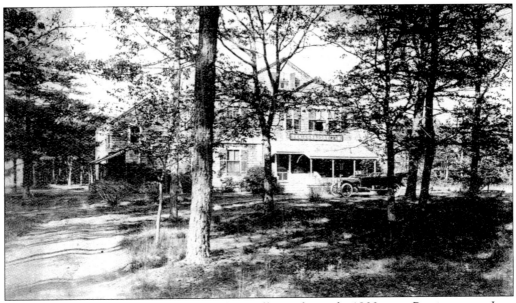

A smaller, more modest guesthouse in Osterville in the early 1900s was Pemigewasset Inn. Still, it rated a featured picture on a postcard taken by the village's most noted photographer, Louis Huntress.

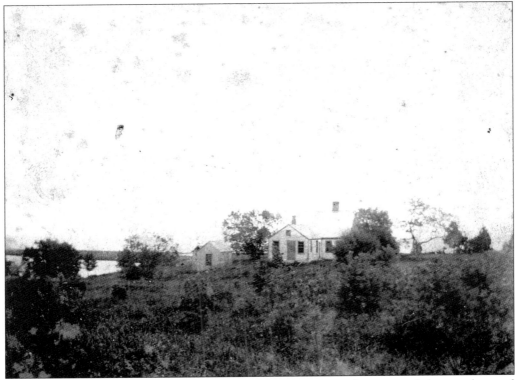

The bluff above the Centerville River offered homeowners a fine view of the marshes and Nantucket Sound. In the early 1900s, this house belonged to the James Lumbert family.

A lone oyster shanty, sometimes called "Uncle Joe's" and sometimes "Uncle John's," stood on the edge of Little Island and was passed down from Crosby to Crosby, generation by generation. In midwinter, the shanty, which faced West Bay and the entrance to Eel River, would have been a frigid, windy place to shuck oysters. Below, a more inviting excursion to a Cape Cod beach in the early 1900s could be enjoyed by strollers walking along the Cotocheset House boardwalk. Sun- or wind-shy guests were invited to seek shelter in the two-story pavilion.

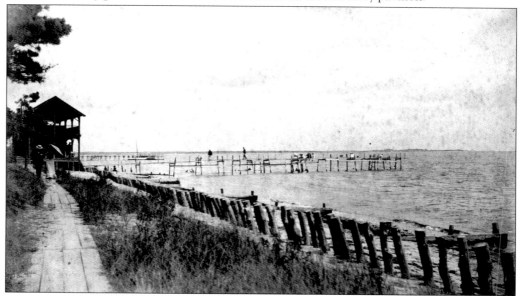

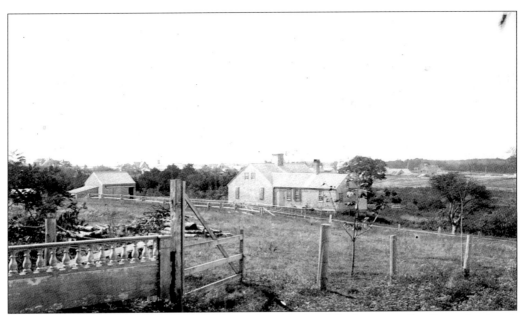

The home of Timothy Parker, and later his nephew Frederick Parker, was a Bay Street landmark in the 1890s. Frederick made his living fishing and oystering and for 25 years crewed on coasting schooners. The farm eventually passed to his only child, Harriet Parker Wetherbee.

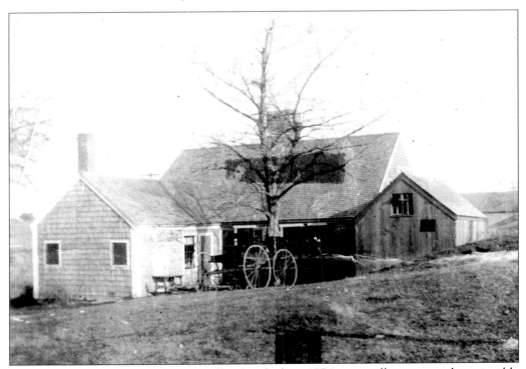

The home of "Deacon" Robert Lovell, who died in 1874, was still a neat and serviceable farmhouse in the early 1900s. He and his wife, Jerusha, raised 14 children here. In the late 1800s, the Howard Lovell family lived in the house.

BIBLIOGRAPHY

Chesbro, Paul L. and Chester A. Crosby III. *Osterville: A Walk Through the Past*. Taunton, MA: William S. Sullwold Publishing Inc., 1979.

_____*Osterville: A History of the Village Volume I*. Taunton, MA: William S. Sullwold Publishing Inc., 1988.

_____ *Osterville: A History of the Village Volume II*. Taunton, MA: William S. Sullwold Publishing Inc., 1989.

Crocker, Zenas. *A History of Oyster Harbors to 1994*. Oyster Harbors Property Owners Association Inc.

Deyo, Simeon L. *History of Barnstable County, Massachusetts*. New York: H. W. Blake & Co., 1890.

Leonard Family. *Osterville _ Twice Remembered*. Osterville, MA: Parker Press, 1986.

Trayser, Donald G. *Barnstable*. Hyannis, MA: F. B. & F. P. Goss, 1939

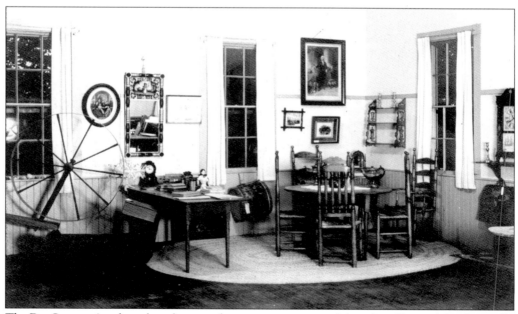

The Dry Swamp Academy later became the community center (above) and housed the Osterville Historical Society. In 1949, the society moved its collection to the Daniel Crosby House on Bay Street. In 1961, the Jonathan Parker House became its permanent home.